Drawing Archaeological Finds

Nick Griffiths and **Anne Jenner**
with **Christine Wilson**

First published in 1990 by Archetype Publications Ltd.
Revised Edition 1991, reprinted 1996, 2002

ISBN 1 873132 00 X

Printed in the United Kingdom by Henry Ling Limited, at the Dorset Press, Dorchester, DT1 1HD

Contents

Acknowledgements

We are very grateful to the following for their permission to use illustrations commissioned by them, in some cases in advance of their own publications: Martin Biddle (Winchester Research Unit); Joanna Close-Brooks; Arthur MacGregor (Ashmolean Museum); Alan McWhirr (Cirencester Excavations Committee); Dr Paul Robinson (Devizes Museum); Peter Saunders (Salisbury Museum); David Viner (Corinium Museum, Cirencester); and to many colleagues and ex-colleagues at the Museum of London, especially Christine Jones, Frances Pritchard, Brian Spencer and Tony Wilmott. We should also like to thank English Heritage for permission to publish Figs. 43 and 44, and the Trustees of the British Museum for Fig. 15a; both of whom retain the respective copyrights.

The illustrations are the work of the authors, with the exception of those kindly provided by the following: Barbara Davies (Fig. 50); Susan Goddard (Figs. 43, 44); Emma Hunter (Fig. 17e); Redenta Kern (Fig. 8); Susan Mitford (Figs. 18e, 23c, 23e); Jacqui Pearce (Figs. 40b, 45c, 45f, 51, 57a); John Pearson (Fig. 20b); Richard Tambling (Fig. 14g).

We are also grateful to Clare Conybeare and Patrick Read for reading and commenting on the text, Jenny Finkel and Catherine Pearce for typing, Mic Claridge for design and Jenny Siggers and Louise Ferri for typesetting, Keith Bennett and Trevor Dooley for advice on printing; and finally, Jim Black for his encouragement.

Introduction

This book is intended as a guide to all types of 'finds' illustration from the initial pencil drawing to the final stage of publication. It is aimed at raising the standards of archaeological finds illustration by outlining the general principles as well as the conventions specific to each different type of material/artefact. Each process is explained in detail with accompanying diagrams, references and examples of what the authors feel are 'good' illustrations. What then, is a good illustration? It is one which incorporates an understanding of the component parts of an artefact with an ability to make an accurate and aesthetic rendering of its character. It should have a lasting quality despite the fashions and preoccupations of the day. Artefacts may be lost, stolen, broken or simply decay, but a well executed illustration will act as a true record of the artefact and its material condition despite its subsequent history. However, it isn't enough to make an illustration which fits all the above requirements if it is never published, and it is useless if no-one other than the illustrator and author ever see it.

A bad illustration is one which fails to fulfil any one of these categories (see Dillon 1979). Unfortunately there are a surprisingly large number of these, suggesting the need not only for a book of this sort, but also for more professional training in this area.

We have already established the importance of publishing archaeological finds, but why illustrate them at all? Why not just write about them? It is always better to have a picture of an object in front of you than any number of sentences explaining it, as no amount of words could be expected to sum up all the characteristics and components of an artefact in sufficient detail for the mind to reconstruct the object in its entirety.

The next question people ask is, why not just get a good photograph? There are a number of reasons why an illustration is almost always more informative. A drawing conveys information on an object's shape, size, form, method of manufacture, number of components and thickness of its walls. This is all portrayed in a series of elevations, plans and sections which would not all be possible using photography alone. If an artefact is worn and its decoration faded or decayed, even the best lit photograph will not be able to display all its characteristics accurately. A close study of the object is integral in the illustration process and this often sheds light on important details which can then be picked out and emphasized. The camera cannot always do this (Fig. 1).

The illustrator can also make diagrams or simplified line drawings to clarify certain decorative elements (Fig. 1), and when necessary play down features which are thought to be less significant. This must be done with care so as not to make the subsequent illustration too subjective. The surface texture on a highly patterned object may, for example, be played down or even omitted in areas of dense decoration as this would detract from the pattern and confuse the picture. Sometimes glass which has striations of colour within its fabric, as well as a highly decorated surface, may be illustrated in two separate drawings (Fig. 2). These elements cannot be separated out in this way with the camera alone.

Light reflected off the surface of an object can distort its appearance in a photograph. The illustrator can make accurate measurements and drawings even when working with highly reflective surfaces.

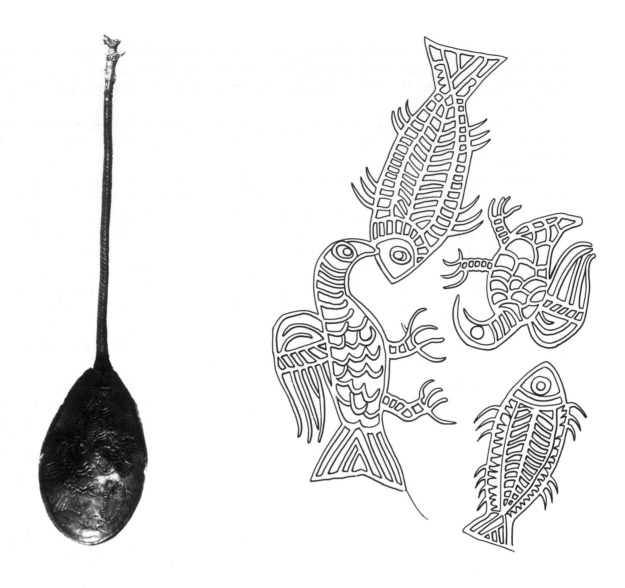

Fig. 1 Photograph of metal spoon (left). Illustration of design on spoon (right)

Perhaps the most important point is that line drawings can be reproduced more cheaply than photographic plates. This is an appropriate place to discuss printing since, by one method or another, this is the essential step which turns the illustrator's work into the illustration seen by the reader.

The traditional block-making process has now been largely superseded by the cheaper process of photo-lithography, but is occasionally still used as it usually gives a better quality print.

In the traditional block-making process the artwork is photographed and the negative printed onto a zinc plate covered in light - sensitive emulsion (a "zinco") where black lines on the drawing appear as clear areas and white areas as black. The plate is then washed in acid, which etches away the black areas, leaving only the clear parts standing proud. After cleaning to ensure a clear print, the plate is mounted on a wooden block. The block can then be set up with lettering and both printed at the same time.

Most archaeological publications today are printed using photo-lithography. In this process light is passed through a photographic negative of a drawing (or text) onto a thin metal plate which is coated in light-sensitive emulsion. This stage is very similar to

developing photographic prints. The negative of the drawing will be white lines on black. Light passes through the white lines and reacts with the emulsion to transfer the drawing as water-repellent lines on the plate. The rest of the emulsion is then washed off and the plate is left wet.

An oil-based ink is used which sticks to the water - repellent lines on the plate but not the wet areas. The ink-loaded lines then print in the same way as the raised lines on the traditional block.

Line drawings are better for printing than photographs. Drawings reproduce accurately whereas printing photographs can introduce distortions that are expensive to avoid.

Photographs can be printed, but only after going through an intermediate stage; they are re-photographed through a screen or fine mesh; the resulting pattern of dots retains the various tones of the photograph, as the darker the original tone, the larger the dot.

The paper quality affects the fineness of the mesh that can be used, as on cheaper, coarser papers (often used for cost-conscious archaeological publications) the image will appear very grainy. Look at a newspaper photograph to see how the image is formed.

If photographs are essential, there are ways round the problem. One is to print the photograph on glossy paper which is expensive but gives good photographic reproduction. This is then bound in with the other sections of the book.

Finally, a more recent development should be mentioned which is the cause of much controversy amongst archaeologists. This is the cost-reducing method of reproducing text and illustrations on microfiche sheets. These are film sheets, of approximately postcard size, which contain a large number of highly reduced pages; up to <u>98</u> pages per fiche. These are so small that they can only be used in conjunction with a viewing screen, where the fiche can

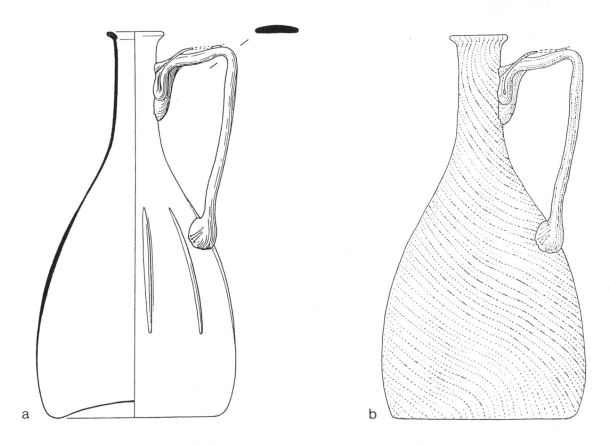

Fig. 2 Two views of a glass vessel; (a) the usual method of depicting glass, (b) a separate drawing of the same vessel to show striations within the fabric.

be adjusted to project the desired page onto the screen, and are not related to the scale of the original artwork. They also tend to appear in white on a coloured ground, e.g. blue. This has the visual effect of reversing shading - black shading appears as white, and the eye 'reads' this as a highlight, the reverse of what is intended. It is possible to have the fiche reproduced as A4 size photocopies, but not necessarily to the scale required, and this facility is far from common. Indeed, the viewing screens ('readers') are rare outside libraries.

For the illustrator, it is the question of scale which is the problem. Any illustration that is going to be reproduced as a microfiche <u>must</u> have a drawn scale included with the artwork (see section on scales (p. 7)).

There are times when a photograph may be of more use than a drawing, e.g. when trying to depict colour (see colour conventions: pp. 46, 74-5) but even then a colour photograph would be combined with an illustration of the elevation and section in black and white.

Today the archaeological illustrator tries to convey as much information on how an artefact was made, the material it was fashioned from, and still make an aesthetically pleasing drawing. All this is done by studying the artefact closely in conjunction with a specialist and then making a number of measurements which will be checked and rechecked to ensure their absolute accuracy.

Different materials/fabrics and textures are all depicted by means of slightly different combinations of lines and broken lines, dashes and dots of varying densities.

The direction of lighting and method of projection is always constant, and the illustration can usually be classed somewhere between an artist's and a scientist's presentation of the facts.

Historical Background

The earliest illustrations of artefacts appear in paintings and manuscript illuminations. For example, various rings and jewels owned by St. Albans Abbey were illustrated in a manuscript by Matthew Paris, a monk, in the mid-13th century, and a number of 15th century manuscripts contain margins filled with coloured drawings of contemporary pilgrim badges. Many Flemish painters were particularly fond of detailing the costume, domestic articles and other artefacts of the day. These are incidental inclusions rather than intentional studies of the individual objects themselves, but they can be extremely detailed.

Pieter Bruegel (1525 to 1569) painted a number of pictures informative for the archaeologist studying European fashions. His depiction of a "A Country Wedding" painted c. 1565, gives a great deal of information on the costume, utensils used for eating, and musical instruments. Many of his pictures included this sort of detail, as did those of Hieronymus Bosch (c. 1450 to 1516).

"The Betrothal of the Arnolfini" by Jan van Eyck (painted 1434) depicts clearly the costume and 'pattens', or shoes, of the day. In fact similar pattens have been found on a number of excavations of waterfront sites in the City of London. These and the work of many other artists can be referred to by the illustrator in order to find out more about the domestic objects of a given period.

It was not until the 18th century that studies of individual objects became really popular, (Fig. 3) although they had been in existence since the 17th century. Antiquarian pillage led to a number of illustrated publications of grave goods such as Thomas Browne's "Urne Burial" (1658) which clearly shows several pagan Saxon burial urns. In 1677, during the construction of St. Paul's Cathedral, a Roman pottery kiln and complete pots were discovered, and drawn by John Conyer. Although the pots are shown in a pictorial manner, the types are quite recognisable. Many of these were exquisitely produced, often as engravings and etchings, but give little information on manufacturing techniques and actual

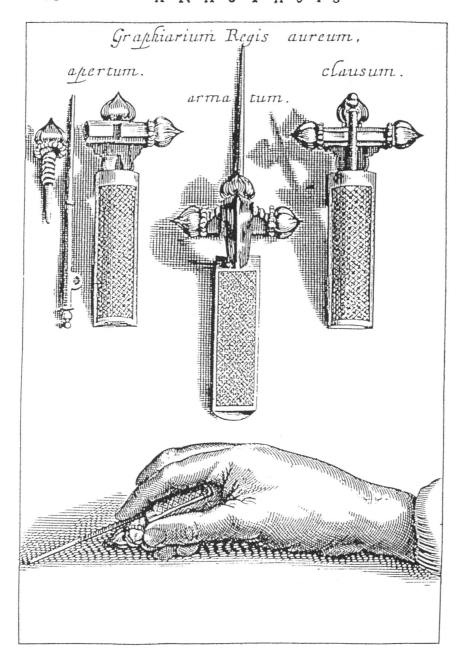

Fig. 3 18th century illustration of a late Roman gold brooch, mistakenly identified as a "Royal golden engraver"; an early attempt at shading to suggest 3 dimensional form..

dimensions. However, in their often painstakingly detailed approach they frequently give a lot of information on details of decoration which, due to poor conservation in the past, may be difficult to discern from the piece itself. Unfortunately a lot of irrelevant detail was also frequently depicted. One example of this is to be found in Alexandre Sauzay's book on "The Marvels of Glass-Making in All Ages" (1870). Here the reflection of a window is depicted in a glass decanter which, of course, does nothing to clarify the object itself but is nevertheless a very accomplished illustration (Fig. 4).

During the 19th century, archaeology was generally a pastime for wealthy land owners and clergymen, but in the latter part of the century a more scientific approach grew up, notably with the work of General Pitt-Rivers. His carefully recorded excavations were followed up by detailed publications incorporating large numbers of engravings of the objects discovered. These are perhaps the first drawings in a recognisably modern style; they

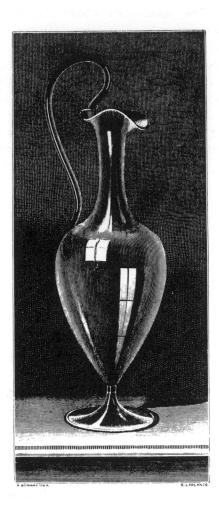

Fig. 4 19th century engraving of two glass vessels from "The Marvels of Glass-making in All Ages" by Alexandre Sauzay (1870).

combine a high degree of accuracy with an artistic shading that gives a convincingly solid look to the drawings.

Pitt-Rivers' style set the standard for most archaeological drawings through until the 1930s, and highly shaded 'solid' drawings were the norm until the 1960s. Styles varied in detail, but the most accurate drawings tended to be more elaborate, shown notably in the illustrations published by the British Museum between the two World Wars, and in the publications of Sir Mortimer Wheeler.

The growth of archaeology in the 1960s and 1970s, and the pressure of rescue excavation work led to a great increase in the amount of archaeological illustration undertaken, and a drastic change in quality. Large numbers of illustrations were produced by people with little or no training in art or archaeology. As often happens, a complete over-reaction to the previous 'artistic' representations occurred, and many archaeological reports contain simple outline drawings of objects, sometimes with a crude attempt at basic shading; a certain similarity of approach to engineering drawing conveyed the false impression that these were 'simple but accurate' portrayals. Often merely drawing round the object was considered sufficient. In practice, such a drawing merely hints at the type of object concerned, but gives the viewer no real information.

In the 1980s there has been a gradual improvement in both accuracy and style. The work of illustrators who 'learned their trade' in the 1960s and before has gradually had an influence, and many who came into the profession in the 1970s have discovered from their own experience that more is needed than simply a sketchy outline.

Nowadays, a combination of both artistic and scientific approaches is evident; many illustrations are more detailed and more convincingly portraits of three dimensional objects,

yet without becoming too elaborate or over-fussy. The results are more attractive as illustrations, yet convey the maximum amount of information to the reader. This is partly through the introduction of more conventions, in order to make the illustration as objective as possible. Established conventions help several illustrators working on one project to produce drawings that conform more closely in style. This is often known as a 'house style'; comparison between a work where several illustrators have drawn completely independently, and one where several have worked to a common style reveals several points. The former makes a far less visually pleasing - often very messy - page, which raises questions of accuracy. A page where the drawings, even if identifiably by different hands, conform to a style, suggests a measure of control over style and accuracy, and is more likely to be a trustworthy source of accurate information.

General principles

Unfortunately the standardisation of the techniques used by illustrators of archaeological material has never been fully discussed and, although there are a number of standard conventions, there are also a number of different methods in use in different parts of the world today.

Despite this there are certain universally accepted aims and only a limited number of ways of achieving them. The archaeological illustrator should aim to produce a clear and neat representation of an artefact which can easily be interpreted by any reader to reach the same conclusions. To do this certain broadly accepted principles can be applied. These are explained below.

Light

The object is always illustrated as if the light were coming from the top left hand corner of the page, even when this has to be imagined, which is often the case.

Study the object

The object should always be studied first and decisions made as to what to include, miss out, emphasize and play down. If it is not possible to tell what the object is because of corrosion, a faithful representation should be made. Sometimes a quick sketch at this stage may be useful in order to note details of decoration and manufacture.

Scale

Before putting pencil to paper it is important to decide on the scale most suited to the object. 'Bulk' finds such as building materials and ceramics are normally drawn at a scale of 1:1 and reduced to 1:4 or 1:3 in the final publication. 'Small' finds; pins, brooches etc. are usually drawn at a scale of 2:1 for publication at 1:1, though some large objects, i.e. tools and weapons etc. are usually drawn at 1:1 for reduction to 1:2. The scale used is dependent upon the size of the object and the amount of reduction intended (see p. 23).

Some pottery is reduced to 1:3, and some, e.g. Samian ware to 1:2, but generally pottery is reduced to 1:4.

Drawings are reduced for several reasons; clearly many objects and pots are too large to fit the average page size; it is uneconomical to publish many objects at actual size, when this would result in only one or two per page. Again, many small objects need to be drawn 'larger than life' in order to fit decoration and fine detail into the drawing; the drawing will then usually be reduced back to actual size for publication. Reduction has the added benefit of reducing flaws, and generally makes the drawing appear 'crisper'.

When drawings are reduced, there is a tendency for the ink to "block-in" any lines that are too close together. It is impossible to give rules on how to avoid this, as much depends on the sharpness of the printer's negative, and the amount of ink applied at the printing stage. Photocopies with a reducing facility can be used to check the likely effect, although as the photographic process involved is different, it is only an approximation. It is also possible to obtain a 'Reducing glass' - which whilst looking like a magnifying glass, enables one to see how a reduced drawing will look.

Although it is impossible to give absolute rules for degrees of reduction, certain guidelines are possible. Firstly, it is easier for the user of the drawings if they are kept to certain simple proportions, e.g. 1:2, 1:3, 1:4, 1:6, 1:8; in each case it is relatively easy to estimate the full size of an object from the drawing. This is not the case with scales such as 2:3, 3:5, 4:7, 7:8, etc.

The degree of reduction necessary may depend on the eventual print area of the publication, so if possible this should be ascertained at an early stage. Having decided on the scale to which the objects are to be reduced, there is a simple rule for the best pen sizes. The thinnest line which even an indifferent printer should be able to print is 0.1 mm.; less than this, and flaws and breaks will appear. Therefore, if 0.1 mm. is multiplied by the degree of reduction, the size for the thinnest 'safe' line is reached; e.g. for 1:4 reduction, 0.4 mm. pen; for 1:2 reduction, 0.2 pen. With a good drawing, and a good printer, a finer line (e.g. 0.3 pen for 1:4 reduction) will probably reduce and print, but generally it is advisable to follow the above rule.

If objects are reduced accurately, and the caption to the figure makes the scale clear, there is no need to add a drawn scale to the illustration. Often, the actual height or diameter of an object will be mentioned in the text. However, as described above, drawings intended for microfiche reproduction require a drawn scale, and this should be as simple and unobtrusive as possible. For example, a simple line marked with centimetres is quite sufficient to show the scale of the objects.

Orientation

It is important to decide on the principal view(s) of each artefact before drawing it (see relevant sections). Where possible the front, back, top, bottom and sides must be determined in order to orientate the object correctly. The vertical axis of the object can then be aligned parallel to that of the page.

In some cases it may only be necessary to show two views; front and side or section. Other more complex ones may require a series of views. Common sense will play a large part in such decision making. When a number of views are to be illustrated, the object is always rotated 90° to the right until four views have been completed (front-side-back-side) if these are all necessary. This is a general rule.

The subsequent drawing gives a clear picture of the number, size and shape of the constituent components as well as a clear indication of how they were put together. Sometimes it is impossible to determine exactly how an object was made and where one component starts and another stops. In this case an X-ray can be taken and used in conjunction with the object itself to determine the exact positioning of each part.

Securing the object to the page

Some illustrators use their free hand to hold the artefact, but others find it helpful to fix it into position on the page. White plasticine is particularly useful in this respect, and can be stuck onto white card in order to avoid soiling the paper. Be very careful not to use plasticine with fragile objects, as there is the danger of pulling off the surface!

Sections

A section is an imaginary view of an object cut across its breadth and occasionally its length. A true section is taken at 90° from the edge of the object, not obliquely across it as this would give a false picture of its shape.

Short lines are used to show where the section is taken from as well as to connect various views of the same piece. This is so that they will not be confused with other objects drawn or pasted up on the same page. However, pottery, glass and other cylindrical vessels are drawn in two halves with a complete section taken through the length of the vessel and shown on the left. Connecting dashes are only used for handle sections in such circumstances (Fig. 2). Sections are either outlined and left plain, blacked in or hatched. Hatching is always done with lines at 45° from the horizontal, starting at the bottom left hand corner and finishing at the top right. For further details see chapters on individual artefacts.

Hatching can be done quickly by machine or, when there is no machine available, by hand (Fig. 5a). To do this a T-square is placed across the page at 90° from the vertical edge with a ruler above and adjacent to its upper edge. (Some T-squares have measurements marked on them, in which case a ruler will not be necessary.) A 45° angled set square can then be placed above that so that the 45° angle is on the left and the 90° angle on the right hand side, and moved along the ruler/T-square at regular intervals and equidistant lines drawn.

A simple method of hatching at 45° using only a pencil and ruler (Fig. 5b)

First, draw horizontal and vertical axis lines above and to the left of the section or area to be hatched. The drawing most probably has horizontal and vertical axes already. Next, mark a point at the same distance along each axis from the crossing-point 'a'. The distance doesn't matter as long as it is exactly the same in each case. A line drawn between these two points is at 45° to the axes. Finally, mark two lines of points at the spacing chosen for the hatching, at 90° to the diagonal line. This can be done by eye (with practice) or accurately, by drawing a line from 'a' to cut the diagonal in the centre (measure from each axis) at 'b'. Measuring to either side of this line will give two parallel lines ('c' and 'd') along which the spaced points can be marked. Finally, draw lines between these points and the section has 45° hatching.

Shading and inking in

Artefacts are always shaded as if the light source were coming from the top left hand corner. Imagine a picture frame on a wall with a spot light shining down onto its top left hand corner. The two darkest areas will be the inside of the top and left hand edges, and the outside of the bottom and right hand edges. Dark areas are seldom totally black, but light ones are often left white. All details of shape, texture etc. are inked in using different spatial arrangements of dots and/or lines (normally one or the other and seldom both together). They are placed closer together for darker areas and further apart for lighter ones. This is the only way that changes of tone and texture can be indicated. This may sound very limiting, but there are a surprisingly large number of variations which can be made on this theme.

Pen sizes chosen to suit reduction have been mentioned above and a few other points are worth considering. Some illustrators like to ink over an outline pencil drawing only, putting in details as they go along; others like to build up the shading, either as soft pencil shading, or as areas of pencil lines and/or dots. Whichever way is followed (and it is very much personal preference), remember that the drawing will look lighter once the pencil is erased, leaving only the ink. It is always easier to add some extra lines or dots at this point, rather than trying to remove them from too dark a drawing. Always keep the object in front of you when inking, for reference. Do not leave the pen on the surface of the paper for too long in one spot, or the ink may bleed into the surface of the paper, especially on cartridge paper. The pen should be gradually lowered onto and lifted off the paper in a smooth, gliding

Fig. 5a A method of hatching by hand

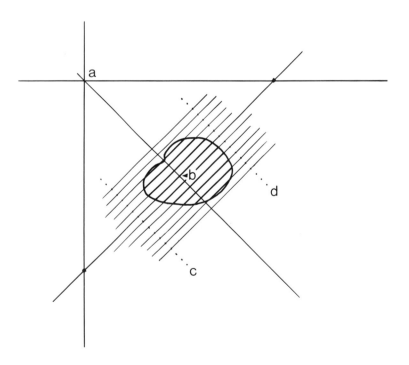

Fig. 5b Hatching at 45°, using only a pencil and ruler.

movement, to achieve an even line. Dots should be made using an equal amount of pressure, otherwise some will be larger than others. Dotting or 'stippling' at random is harder than it might look: there is a natural tendency to put dots in lines and to build up patterns, and it requires concentration to achieve a truly random effect. The point mentioned in the section on reduction concerning minimum line weights applies equally to dots; but it should also be borne in mind that too large dots give a 'spotty' look to a drawing rather than the effect of surface texture. Remember that the pen should be held at a fairly steep angle to the drawing. If the angle is altered, the line width will vary. It is advisable to practise even and controlled penstrokes before starting on the actual drawing, and even the experienced illustrator will have a piece of scrap paper handy to try out pens. It is also worth using photocopies (fairly light) of the pencil drawing, to try out shading before committing to pen the final drawing.

Setting up a drawing office

The room

It is important to choose a clean, dry, dust-free area in which to work and store equipment and drawings.

Lighting

The illustrator needs lots of light, the best and easiest on the eyes being natural daylight. An ideal room will therefore have plenty of windows placed where they will receive as much daylight as possible. Ceiling and desk lights will be necessary. If strip lighting is used, daylight bulbs are better than ordinary ones.

Each desk will ideally have an adjustable desk lamp or similar which can be shone down onto an object from any angle (in this case usually from the top left).

Desks and chairs

Each illustrator will require a flat, even, desk surface to work on. Adjustable desks and chairs are made specially to minimise back strain.

Ideal drawing office facilities

Well lit room (dry and clean), preferably with a north light in the northern hemisphere
Desks with a flat or adjustable surface
Ideally one adjustable desk lamp per person (to be placed on left)
One chair each (preferably adjustable)
Filing cabinets to house catalogues of equipment, lists of work, correspondence, etc.
Plan chest to store drawings
Shelves for publications and sources of inspiration
A cupboard to store equipment
A Grant Enlarger for enlarging and reducing
Photocopier
Paste up, cutting and gluing areas
A sink and cleaning area
Light box

Illustration materials

This section is divided into a check list of essential items and a list of non-essential, but often useful, equipment.

Any equipment specific to the illustration of a particular type of material will be demonstrated at the beginning of the relevant section. For example rim charts used for pottery illustration will be discussed in detail in that section and only given a mention here.

Essential

Pencil (wood-encased or clutch) with leads 2H to HB.

A blue pencil for marking illustrations with instructions to the printer. This colour does not reproduce in the printing process.

Eraser (white plastic type) for erasing pencil.

Pencil sharpeners.

Scalpel - a rounded (Swann Morton 10), or pointed (10a) blade, for erasing ink from film and for sharpening pencils.

Process White and a paint brush, or typing correction fluid, for covering mistakes in ink on cartridge paper.

Dividers - these should be firm with fine points. Metal ones are more substantial and better made than plastic, which are cheaper but may prove to be a false economy.

Drawing board - it is important to pick or make one which has a smooth, flat surface and 90° angles so that a T-square can be used with it

T-square - make sure this is flat and right angled. It is an advantage to have a clear plastic arm with measurements marked on it.

Adjustable set squares - may be useful but the only two necessary ones are a 45° one and a 30°/60° one. Metric measurements are useful on one side.

A clear plastic ruler, marked in centimetres and millimetres; inch markings can also be useful.

A steel ruler or straight edge for use in cutting.

A cutting surface, i.e. a piece of board or old desk top which will not be ruined if scratched and cut.

Cartridge paper and film - A2, A3 and A4 are the most useful sizes (see pp.17 and 18).

Card - white card is used for pasting up illustrations and photographs. It can be bought in sheets of A1 size and cut to the required size. It is marketed under various names such as "mounting card", "Glory Board", etc.

Technical pens - the most useful are the tubular nibbed variety and sizes 0.2 mm. to 0.6 mm. are most commonly needed.

Cow Gum and spatula for "pasting up".

"Invisible" or "Magic" tape is used to stick drawings made on tracing paper or film onto mounting board.

Masking or drafting tape is useful to hold the paper in place on the drawing board.

Ink - black suitable for tubular nibbed drawing pens.

'Instant' letters and numbers for numbering pasted-up illustrations for final publication.

Stencils of letters and numbers - these can be used instead of the above.

Engineer's square - although not essential for illustrating many small finds, this will prove extremely useful for some larger items, ceramics and building materials.

Calipers - essential for pots, and may be required for other objects.

Non-essential

Compass with extension arm and nib attachment for drawing circles.

Paint brush or size 1.0 mm. or larger pen for inking in large areas.

Proportional dividers - can occasionally be useful for scaling objects up to odd sizes, e.g. 3:5.

Tracing paper.

Graph paper - to help scale up or down (see p.26).

"Stanley" or craft knife for cutting card, etc.

Guillotine for cutting card, etc.

Fine sand paper for honing the pencil lead to a fine point.

Profile gauges; template formers; "toothcombs". These can be pressed lightly to the surface of a solid, non-fragile object to give a rough guide to its shape. Soldering wire can also be used for this purpose.

French curves, circle and ellipse templates - for drawing curves of varying radius.

Hatching machine.

Cleaning fluid.

Reducing glass.

Light box.

Tissue paper, e.g. cigarette paper, for making rubbings.

White plasticine.

Graphite powder

It is not necessary to elaborate on all the equipment listed above as much of it will already be familiar, and that which is not commonplace will be explained in the relevant chapters. Here we will describe the most essential items; the options available and how to use and keep them in working order.

Pencils

9H 8H 7H 6H 5H 4H (3H 2H H F HB) B 2B 3B 4B 5B 6B EB EE

Traditional wood-encased pencils come in a range of 19 hardnesses but the archaeological illustrator should only ever need one of five in the middle of the range (see above). The harder pencils (H-9H) produce fine precision lines for draughting but can carve lines into the paper when too much pressure is applied. These are difficult to erase and look untidy. If too little pressure is applied the line will be too fine and difficult to see. The softer the pencil the easier it is to erase but the thicker the line, unless sharpened constantly, and the wider the line the less accurate the image is likely to be.

The medium to be drawn onto must be taken into consideration when choosing the right pencil. Generally a harder medium requires a harder pencil and vice versa.

Grades F and HB both combine the optimum in fine line, softness, and easy erasure for use on the softer medium of cartridge paper. 2H and H grades can be used on tracing paper which is a little harder. A 3H is needed for work on plastic film which is harder still. Special film drawing pencils can be obtained, numbered in a series V1-V4, though these are similar to the higher H numbers.

Clutch pencils with leads in the same range of hardnesses can be bought in four different sizes (0.3, 0.5, 0.7, 0.9). These coincide with certain ink pen sizes. They keep a constant line width and offer some resistance to hard plastic papers. The 0.5 is recommended here as the 0.3 has a tendency to snap and the thicker ones produce a line too wide for precision work.

Sharpening the pencil

It is very important to keep the point of the pencil as fine as possible in order to be accurate.

Wood-encased pencils are often sharpened using pocket or bench sharpeners, but these do not always render the point fine enough for precision drawing. The scalpel blade can be used to shave off excess wood and with experience, a constantly fine point can be achieved in this way. The pencil should be held over a waste paper bin with the butt end closest to the body and the scalpel should be used to cut away from the body (Fig. 6). Some prefer to use a bench or pocket sharpener and then hone the point down further with a scalpel, others use the scalpel alone.

Some clutch pencils have an inbuilt, detachable sharpener but those which do not have such a device can be sharpened in manual or electric 'pointers' in which the pencil is rotated against grinders.

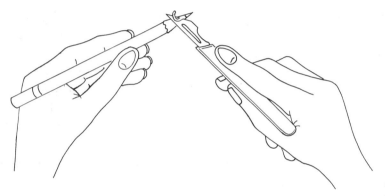

Fig. 6 Sharpening a pencil with a scalpel.

Paper and film

When selecting a drawing surface it is necessary to know:

i) whether it is intended for a rough draft or final copy;

ii) whether it will reproduce well;

iii) whether it is suitable for pencil and pen and ink drawings;

iv) the final effect.

The surfaces used for most purposes are plastic, cartridge, tracing, graph, and rough sketch pads for notes.

a) Clear plastic film is a hard wearing, non-absorbent medium which lends itself well to pencil and ink work. It is made from polyester or acetate and comes in pads or rolls, usually in the A paper sizes. The two most common thicknesses are two thousandths of an inch and three thousandths of an inch (0.002" and 0.003" respectively). The rolls are normally 841 mm. wide (see A1 in the A paper sizes), by 20 or 25 metres long.

Points worth noting about film are that while it takes ink well, it also picks up grease and dirt easily, and a finger mark can make a spot where the ink won't adhere. Such marks can be removed with a hard eraser, though this may slightly damage the surface. Ink can also take some time to dry, especially in a warm atmosphere, when it will stay 'sticky', sometimes for several hours. It should be remembered that the ink doesn't soak into the film (as it does with paper) but dries on the surface; too vigorous erasing can easily remove the ink. A sharp

blade can be used to scrape ink off the film, a useful method of erasing mistakes, but it must be done with care; a cut in the surface is irreparable and will cause lines to 'bleed'.

b) Cartridge paper is graded according to its weight (thickness) and tooth (degree of surface texture). It is sold in pads or loose sheets.

When buying paper quote its vertical dimension first and then the weight per square metre of a single sheet. The abbreviation for this is gm.2 or gsm. 120 gsm. is thick enough for most purposes. It is advisable to combine a smooth texture with a relatively non-absorbent body as this will hold ink well without 'bleeding', but it is not necessary to buy the highest quality.

c) 'CS 10': the common term for a polyester-based 'paper'; it combines the texture of film with the appearance of paper. It can be obtained in sheet, pad or roll form, but it can be argued that it should never be obtained in any form! It should always be handled with care as the edges are sharp and can inflict very painful cuts. When clean it takes ink very easily, but as with film, the ink does not penetrate the surface and can be very easily smudged until completely dry. Any dirt, dust or grease can prevent the ink from adhering. Even pencil drawings can be enough to prevent the ink from drying on the surface, and erasing a pencil drawing often removes the ink as well, even when dry, since it has no real bond with the surface.

d) Tracing paper ranges from clear, translucent to opaque, in plain and graphed sheets, pads and rolls. It is used mainly for tracing the outlines of objects where several views are required but can also be used for enlarging.

e) Graph paper comes in a variety of mathematical and technical shapes and sizes with divisions based on metric or imperial measurements. Metric sheets with strongly printed lines at 1, 5, 10 and 50 mm. are sufficient. The polar co-ordinate pads which have a series of concentric circles divided by radial lines at regular intervals are useful for measuring the diameters of ceramics and other cylindrical objects.

Sketch pads are ideal for jotting down dimensions and sketches of complicated objects, and can be referred to in the future when similar objects or problems occur.

Card

a) White card is used for pasting up final drawings but can also be used to draw on. Illustration board has a high quality 'rag' surface with a cardboard backing and either 'CP' smooth cold pressed or 'HP' faint grained hot pressed are suitable for pen and ink drawing.

b) Smooth Bristol board ranges in thickness from 1 to 5 ply - it has a very fine surface for drawing, and takes ink well, but is expensive, and the thicker boards are very stiff and heavy; it does make a sturdy, though expensive, mounting board.

c) "Plasticard" can be bought from most model shops and used to make templates to measure diameters of cylindrical objects.

Paper sizes

The traditional paper sizes are still used for some art materials, including some pads of cartridge paper. Common sizes are:

7" x 5" (178 x 127 mm.)
10" x 7" (254 x 178 mm.)
11.5" x 9" (292 x 228 mm.)
14" x 10" (355 x 254 mm.)
20" x 15" (508 x 381 mm.)

From the 1970s onwards the I.S.O. (International Standardization Organization) paper sizes have become common, and most paper, card, film, etc., is produced in the metric A sizes. These are based on a sheet, A0, which measures 841 mm. x 1189 mm. Cut in half, parallel to the shorter dimension, it produces two sheets of size A1, exactly the same shape as A0. A1, cut in turn, produces two sheets of A2 size, and so on (see Fig. 7). The A sizes:

A0 = 841 x 1189 mm.	A4 = 210 x 297 mm.
A1 = 594 x 841 mm.	A5 = 148 x 210 mm.
A2 = 420 x 594 mm.	A6 = 105 x 148 mm.
A3 = 297 x 420 mm.	A7 = 74 x 105 mm.

Of these A1 - A4 are likely to cover almost all archaeological drawing requirements.

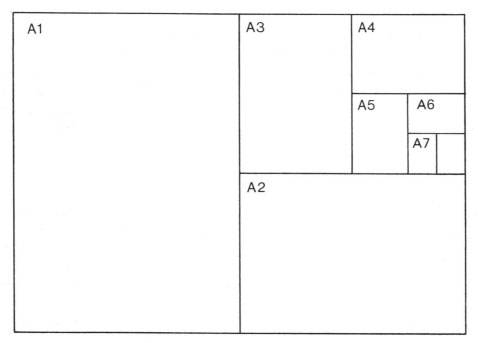

AO : 841 × 1189 mm

Fig. 7 The 'A' paper sizes

Pens

Traditional dip pens and fountain pens (with sac or cartridge ink reservoir) have flexible nibs which give different line widths according to the amount of pressure applied. These can be useful for illustrating flint artefacts which require tapered line shading to denote the shock waves on each scar present.

"Graphos" pens have numerous interchangeable flat nibs which give different line widths; they have an integral or cartridge reservoir and can be fitted with one of three feeds which control ink flow speeds. The most useful nibs are the freehand and technical drawing ones. Unfortunately the range has been reducing for some years, and the "Graphos" nibs are now very hard to find.

Technical pens have tubular nibs with cartridge ink reservoirs. Nibs range from 0.1, 0.2, 0.3, etc. to 1.2 mm.

European (metric) point sizes are usually given in millimetres. The most useful point sizes are: 0.2, 0.3, 0.4 and 0.6. Certain American equivalents are given below. Be careful not to confuse the two. An American 3 is very much thicker than the European 0.3.

European	American	European	American
0.13	6 x 0	0.7	2.5
0.18	4 x 0	0.8	3
0.25	3 x 0	1.0	3.5
0.3	00	1.2	4
0.35	0	1.4	6
0.5	1	2.0	7
0.6	2		

Special technical pens, with toughened sapphire and tungsten carbide nibs, are made for stencilling and work on abrasive film surfaces.

Dotted line pens have interchangeable wheels which give a variety of dotted and broken lines. Dashed lines are used to denote an absent or reconstructed area while dots can be used to reconstruct absent areas of decoration where an idea of the complete original design is required. With a little practice it is fairly simple to produce an evenly-spaced dotted or dashed line with any pen.

Pen maintenance

Technical pens often clog and to avoid this the caps should be replaced when not in immediate use. They can be stored in a humidifier to keep the ink from drying in the pen. Alternatively, keeping them in a moist atmosphere will help prevent the ink from drying.

To get the ink flowing the pen should be shaken up and down. A faint tapping sound will be heard as an internal device hits the top and bottom respectively of the nib unit. The pen is then ready to use.

To clean, take apart and soak in warm water with a small amount of washing-up liquid or a special cleaning fluid. Wash out with water and allow to dry before reassembling.

Aerosol or ultrasonic cleaners can be used but are expensive and unnecessary.

One problem with tubular nibbed pens is the occasional tendency for ink to flood out round the nib. This often happens when the air is warm; the warmth of the hand expands the air in the cartridge, which forces the ink out rather more quickly than usual. There is no certain way of preventing this, but keeping the cartridge fairly full can help.

It should always be remembered that all technical, tubular nibbed pens are designed for use in a clean drawing office, and not in the dusty environment usual in archaeology. It helps to keep them in a closed tin or box when not in use, but they will inevitably require more cleaning than the manufacturer might suggest.

Ink

Special non-clogging ink, which is waterproof, can be bought for tubular nibbed technical pens. Many manufacturers supply special inks with the same brand name as their pens. These often come in sets together with compass attachments and maintenance instructions. Bottles are almost all plastic these days and this is advisable rather than glass which may

shatter when dropped. For certainty, use only the ink produced for a specific pen by the manufacturer. Never use artists' Indian Ink in tubular nibbed pens. It is far too thick and will clog fine nibs very quickly.

Erasing mistakes

When erasing pencil always use a white plastic eraser.

When erasing ink mistakes there are several options, according to the size of error and the type of paper :

a) Plastic drawing film

i) Use a scalpel blade to scrape off the ink, being careful not to cut too deeply into the paper. (The size 10 blade is rounded at the end and is therefore less likely to dig holes in the film.) Finish off by smoothing or burnishing with an eraser or clean, smooth finger nail if you have one!

ii) Ink rubbers, particularly plastic ones which contain a solvent which dissolves ink, can be used and the paper smoothed afterwards.

iii) Special liquid erasers can be bought for plastic-based materials

iv) Electric erasers can be good for small mistakes but can warp the paper if used over too large an area.

b) Cartridge paper

Cartridge paper should not be scraped with a knife or blade; once the surface is damaged it cannot be satisfactorily restored. Errors in ink should be covered with either "Process White" or "Tippex" (or similar typing correction fluid). "Process White" is a finely ground white poster paint, and is water soluble. It can be painted on with a fine paint brush. "Tippex" and similar fluids can be thinned with their own spirit-based thinners. The lid should be replaced immediately as the liquid is fast drying. The correction fluids dry very quickly; Process White takes 15-20 minutes to dry out completely, may need a second coat, and ink should not be put on it until it is thoroughly dry. Its advantage is that it is far cheaper than the typing correction fluids, and easier to apply on large areas.

Compasses, dividers and calipers

There are a number of different pencil compasses on the market but when choosing one make sure that the join areas are quite firm. If they are loose and wobbly this may induce a loss of precision.

Compasses

Compasses which incorporate pencil and pen attachments are particularly useful for publication drawings of plans of circular objects like ceramic bowls. Extension arms of varying lengths can be added to increase the radius for large circles, while separate small compasses may be required for very small circles. Plastic circle templates of various sizes can be used instead of compasses but do not give the same range of diameters.

Dividers

Dividers can be purchased from most graphics and stationer's shops. They are used for measuring detail and dimensions.

Calipers

These instruments are not often obtainable from graphics shops, but rather from surveyors, mapping and hardware stores. They are used to measure the internal dimensions and sections of open, hollow and irregular objects (see p.61).

Engineer's squares (p.55)

Many experienced illustrators draw the outline of their object by eye, but to ensure that a correctly proportioned representation is achieved, a 90° angle must be maintained from the edge of the object down onto the horizontal drawing surface. Engineer's squares with spirit levels incorporated can be placed touching the edge of the object, and a pencil dot drawn where its corner meets the paper.

Profile gauges or template formers (see p.61)

These are sometimes known as "toothcombs" and were designed for architectural use, but are often used to determine the profile of an artefact. They can be bought from hardware stores but do not be persuaded into buying the newer plastic ones, as only the metal ones are subtle enough for our purposes.

Use them only on non-fragile items such as some ceramics and stone, as they may damage more delicate objects. They can be pushed gently onto the edge of the object to mimic its profile, placed on the page and then drawn round. The subsequent outline must, however, be checked as the teeth on these instruments are often not fine enough to pick out all the details.

Hatching machine

These are not vital but can save a great deal of time when a uniform pattern of hatching is required for colour conventions or shading. They have a detachable ruler which can be adjusted to the required angle. A millimetre gauge sets the distance between each line at a constant spacing. By pressing a button the ruler can be moved and a line ruled. The process is repeated until the area to be hatched is complete. Unfortunately they are expensive instruments, and easily become worn and unreliable.

Drawing objects

Introduction

No matter how good a drawing may be, it can never quite achieve total realism. An object is three-dimensional; both drawings and photographs are only two-dimensional. An object has texture and colour; a drawing may represent the texture, but only a coloured drawing or photograph can reproduce the colour, and here again one is in the area of expensive printing processes.

It follows, then, that even the finest archaeological drawing will only go so far towards the reality of the object. This accounts for the often-heard illustrator's lament that, "it doesn't look quite right" when comparing the object and the illustration. A black and white two-dimensional drawing will never look *exactly* like a coloured three-dimensional object.

A further complication arises from the fact that a pen can only produce dots, lines and various combinations of both. The softness of pencil shading is not available because of the printing limitations, so graduated shadows and highlights have to be produced using only 'sharp' dots and lines. These two 'marks' also have to be used to produce a wide variety of textures and shadings.

What follows is the approach used by the authors and many other illustrators. However, the illustration of objects has even less standardisation than that of pottery, so no claims can be made for the following as the only RIGHT way; it is merely one way that works, is relatively simple, and can be used by most illustrators with little practice. Different people have different approaches and produce equally acceptable drawings. Remember that the end product should be a clear, accurate representation of the object, one that can be reproduced, and not an artistic rendering suitable for hanging in a gallery.

Before doing any drawing, study the object carefully; discover how it is made, the design and extent of any decoration, how many pieces the object is made from, whether anything is hidden by corrosion, and what needs emphasising in the drawing.

Since the term 'archaeological object' can cover anything from a tiny bead to a life-size statue(!), it is clearly necessary to decide the degree of reduction required before one starts drawing. The important point here is to know the size of the eventual page. Knowing this enables the necessary degree of reduction to be calculated. Most objects can be accommodated at actual size (1:1) or half size (1:2). Some tiny objects may need to be published at an enlarged size, e.g. 2:1. Very large objects may have to be reduced to 1:10 or 1:12 to fit the page. In these cases the object is usually measured and drawn at a manageable size, e.g. 1:2 which can then be inked in for reduction by 1:5 or 1:6 to reach the required size.

It is not possible to state exact publication sizes for every type of object, but a few general principles can be helpful. Generally, personal items and items of dress, e.g. brooches, buckles, combs, pins, buttons, beads, bracelets, studs, etc., are drawn at 2:1 and reduced to actual size (ensuring that any decoration can be clearly depicted); tools, knives, vessels,

weapons, etc. are usually drawn at 1:1 and reduced to 1:2. In both cases the ratio of reduction is the same, so drawings at both sizes can be mixed on one page if necessary; indeed, drawings at several different scales can be mounted together so long as the reduction ratio is the same. If, in a group of iron tools, for example, some are too large to be reduced to 1:2 and have to be published at 1:4, they can be separated and mounted as a separate figure; however, if they must all be on the same figure then the large items should be drawn at 1:2 for reduction to 1:4 (or drawn at 1:1 and photographically, or by photocopier, reduced to 1:2, which is then mounted for reduction to 1:4). If this is to be done, remember that the pen sizes will vary according to the degree of reduction.

Having decided on the necessary reduction, the next question concerns the choice of views; how many views and sections are necessary to convey the full information about the object? Usually a side view and/or section are sufficient. The main view should be the one by which the object is most easily recognised. Just as it is Western practice to read a page of text from top left to bottom right, so it is normal to place subsidiary views to the right of, and below, the main view. However, this is not a fixed rule and the views chosen should reflect the complexity of the object. A suitable gap should be allowed between views, varying according to the size of the object.

There is no rule as to how one projects additional views. Figs. 8a) and b) show two alternative ways; in each case the object is turned through 90° whilst remaining in the same plane; i.e. in whichever direction, horizontally or vertically, it is turned, one dimension remains constant. Once the main view is drawn out, the main features can be projected across, up or down, to form a guide for side views. In Fig. 8a) the object is seen as if turned 'under', in each case; in b) it is seen as if turned 'over', with the same action as turning the page of a book. Neither way is right or wrong, but a) does have the advantage that the different views of the faces of the object remain in close proximity; for example, the lion's tail in Fig. 8a, the back view of the tail is nearest the main view of the tail; in b) it is right across to the right beyond the lion itself. One group of objects, namely Roman brooches, are always drawn as Fig. 12a; this is in order to show the form of the catch-plate, which is nearly always set to the right-hand side when seen from the front. Some are set to the left, and are consequently drawn the other way round.

Short lines are drawn to connect the main view to the other views visually. On small objects, this can be about 1/3 of the gap between the views, placed in the centre. A modern practice of drawing two lines between the tops and bottoms of main and side views, almost touching, should be ignored. It is unattractive and at worst confusing, as the lines can appear to be part of the object.

In the case of cross-sections, these are chosen to show the thickness and shape of features, e.g. a knife blade usually has a section drawn to show its thickness and surface shape at a particular point. They can often save the drawing of a side view; they are clearly a useful way of indicating whether an object is solid or hollow. Normally they are projected out to one side or another, or above or below. Knife sections are often placed below the knife itself leaving a suitable gap; if only one section is drawn through an object it can often save space when mounting, if the section is placed below rather than to one side. If space is not a consideration, then it can be placed close to the two small lines used to mark the section point. These should be chosen to suit the size of the drawing. For objects drawn at 2:1, a gap of 5 mm., a 5 mm. line, and a further gap, then the section, is often suitable; however for a thin or narrow object the lines and gaps can be reduced; similarly a large object will require larger gaps and lines.

Having decided on scale, views, etc., and allowed enough room on the sheet of paper to fit everything in, it is now time to start drawing. A useful start is a horizontal and a vertical axis, either forming a cross, or an inverted L-shape. If the object is to be drawn at 1:1, it can be placed on the paper and carefully drawn round; care is necessary or a fragile object might

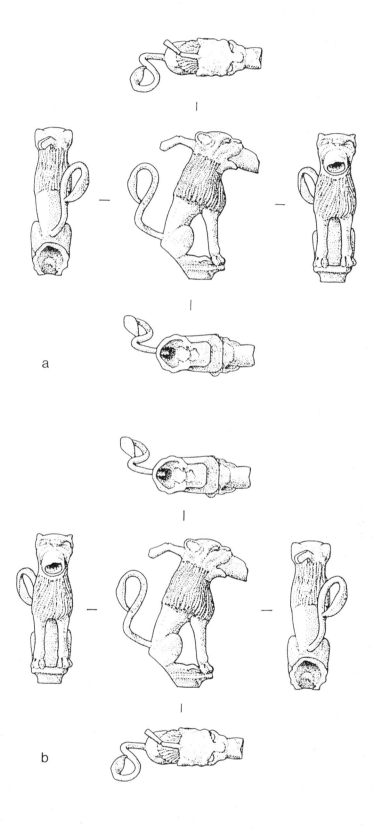

Fig. 8a and b Two alternative projections

be damaged. To draw around the object accurately one's eye must be above the pencil point, and this requires a little practice. Also the pencil's wooden casing may prevent the lead from precisely following the edge of the object. Once a complete outline is on the paper it should be checked dimensionally with dividers to ensure that the outline is accurate.

With a satisfactory outline of the main view on the paper, it is advisable to fill in with the pencil all the necessary details before adding side views or sections. Complete all that is required at each stage before moving onto the next. Certainly all decoration should be marked in, but shading is less important if the drawing is to be inked in immediately. However, it is a useful way of understanding the shape and form of an object to shade it in with the pencil. If, as sometimes happens, the object may not be present when the drawing is inked in, the more shading in pencil, the easier it will be to complete.

For objects that require enlarging to 2:1, various alternative methods are available; it is a matter of personal choice which one uses.

i) Draw round the object carefully on metric graph paper, starting from a fixed point, for example the junction of major vertical and horizontal lines. Alongside, and from a similar fixed point, an outline at 2:1 can be drawn by noting the points where the outline falls, then doubling the number of squares and marking equivalent points. Once the enlarged outline is complete, it should be checked against the object, using dividers to ensure accuracy. It can then be carefully traced off onto cartridge, either with tracing paper, or directly on a light box, or even a window and sunlight!

ii) A variation of the above; where graph paper is unavailable it is easy to draw out a grid using a ruler, with lines, for example, at 5 mm. intervals. Take care that the grid is exactly 90° at the intersections. The object can be placed on this grid and an outline drawn, which can then be transferred by measurement to another grid with squares of 10 mm. width. Again, check the final outline against the object.

iii) Draw a horizontal line and a vertical line, as if to form the top and left sides of a square (Fig. 9). Place the object, at the angle desired, within the angle and carefully draw round it, or mark a series of points, for example corners or changes of outline. The object should be contained within the two lines for simplicity. Having marked the points, use dividers to measure out double the distances from the two axis lines to the points. Points that fall on the axis lines are measured from the intersection along that axis only, all other points are measured from both lines and where the two measurements meet is the new point. These can be joined up, always checking with the object.

iv) A variation of the above (Fig. 10) involves the same two lines at right angles, and the drawing of the object within them; it differs from iii) in that, having established the points, one draws lines radiating out from the intersection point through each of the points. Then the measurements from the intersection to each point is doubled along the radiating line. This establishes a second series of points, which can be joined to provide an outline at 2:1.

With any of the above methods, the number of points chosen can be as few or as many as necessary; a simple rectangular object may need only four or five, a curved or elaborately shaped one can be scaled up more accurately if a large number of points are plotted. To avoid confusion, erase the 1:1 outline once the 2:1 outline is complete.

This is an appropriate place to mention the Grant Enlarger. At first sight this appears to be the ideal answer to drawing objects at enlarged scales. Various models exist, but all operate on the same principle. A large upright framework contains a horizontal glass screen, usually set at about 4-5 ft. above the floor. Beneath this is a movable horizontal lens, and lower down, a movable horizontal table. The item to be enlarged is placed on the table, and illuminated by switching on the machine's built-in lighting. The illustrator places a sheet of tracing paper on the glass screen, and (standing on a box or platform!) looks down through the tracing paper. Above the glass screen, the structure is boxed in at the top, back and sides, to reduce the general light level. Two handles on the front enable the lens and lower table

Fig. 9 Scaling up to 2:1. Dots indicate a typical selection of points. The dashed line indicates the projection
of point A across to the right, then vertically downwards, in both cases doubling the distance from the axes.

Fig. 10 In this figure, only part of the object is shown enlarged for clarity.
Arrows to A indicate the doubling of the distance down the diagonal line.

to be moved up and down on chains, and these are operated until the image comes into focus on the glass screen. Once it has been brought to the size needed (marked in advance on the tracing paper) it can be fine-focussed by rotating the two handles inwards or outwards simultaneously. The image can then be drawn onto the tracing paper. The normal enlargement and reduction limits are x3 both ways (i.e. up to 3:1, down to 1:3).

Having said that it appears to be an ideal answer, certain features need to be noted; the more modern models are less well built and the lower table is held on chains at one side only; it will gradually bend under its own weight, which gives a distorted view on the screen. Older models have powerful lighting which produces considerable heat, and has been known to melt wax used in some restored objects, and also to completely destroy a composite object where different materials expanded at different rates. The lens also has a fairly narrow field of view when enlarging, and anything more than 10 cms. across will be out of focus at the edges. In addition the depth of field is limited, and an object more than 1 cm. deep will have only the top in focus. To sum up, the Grant Énlarger is not recommended for enlarging objects, though it can be useful for enlarging drawings, maps and diagrams, as long as the resulting outline is carefully checked.

The outline drawing is now down on the paper; decoration, details, additional views and sections have been decided upon and added, and as much work done in pencil as desired. If the object cannot be kept for reference during inking in, then the more pencilled shading etc., the better. Remember that the colour of the object is usually of no importance and should be ignored; similarly stains on the surface, unless they form part of an intentional design.

Shading in pencil enables the degrees of light and shade to be worked out. It is best to start with a medium shade for horizontal surfaces; then shade more darkly those surfaces that are sloping away from the light, for instance the lower, right hand side of any raised bosses or studs; the right hand and lower edges if they are bent downwards. It is worth putting a hint of shadow along right hand and lower edges, even where these are very thin, as it helps to give a sense of thickness. Areas that are 'in the light' should be left white, these being upper and left hand edges. If the main surface is flat, the shading should stop in an even line to create a white highlight on the left hand edge. This edge will be clear enough, with no need to delineate the edge of the shading. A curved surface, e.g. a circular domed nail-head, will require a subtle change of shading from the highlit left hand edge across to the shaded lower right hand edge. A concave surface will require a reverse of this shading. Where a second surface lies beneath the front surface and can be seen, it should be given a darker shading; this will help to 'throw forward' the front face, and emphasise the space between the surfaces.

Frequently illustrators define changes of surface shape with a hard line. This has the effect of drawing attention to features that are of relatively little importance. Apart from anything else, changes of shape are only obvious on the object because of lighting, not from any defined line. Ideally, and in practice, the only solid lines needed are outlines and 'real' edges; for example, holes that pass right through the object (e.g. rivet holes), or the edges of additional features such as rivets or attached plates that are individual 'objects' in their own right. If continuous lines are limited to these features, then any other 'lines' can be depicted by emphasising the shading at the appropriate point. A fine line can be formed of dots or short lines, which will, on reduction, look like a line but without the hardness or emphasis of a solidly drawn line. Decoration in the form of incised lines can be achieved in this way, though if the decoration consists of very fine lines, then solid lines can be used but using a finer pen when inking in.

All objects are inked in using stipple or line shading. Stipple is simpler to master than line shading, but needs practice; it is very difficult, at the first attempt, to produce random stippling; the brain seems to want to place the dots in regular rows or patterns, and producing a smoothly graded, random tone can be difficult. Likewise, with line shading,

In the following figures, the pen sizes used for the original drawings are 0.3 for the outlines and 0.2 for the shading unless otherwise stated. For reasons of space, many sections, side views, etc., have been omitted. Reduction sizes are indicated after each description, with the scale of the original drawing followed by the scale of the reduced drawing, (as reproduced here, e.g. 2:1, r1:1).

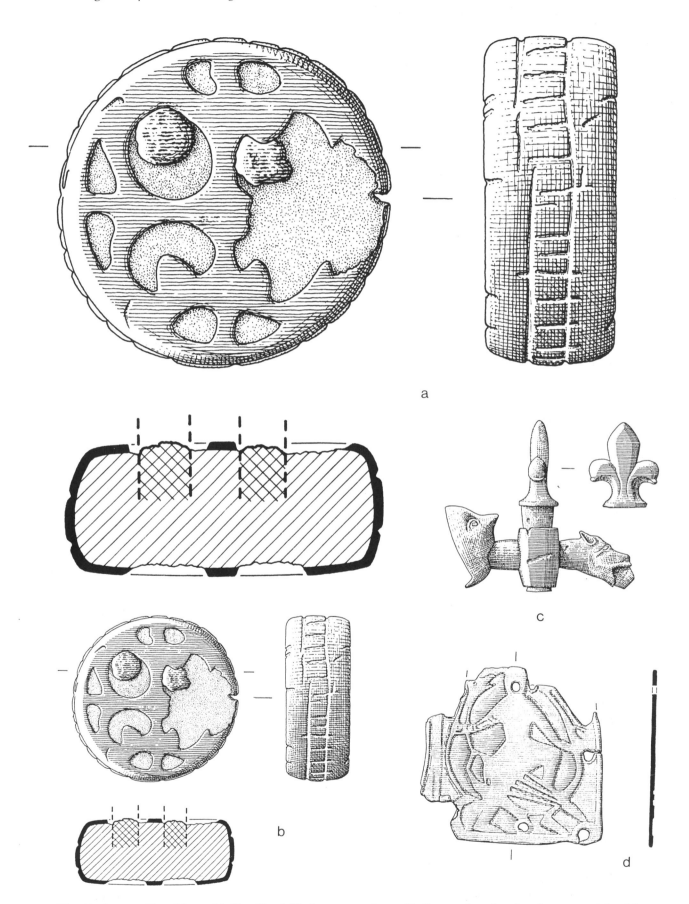

Fig. 11 Copper alloy objects. Medieval lead filled copper casing, with the remains of an iron loop : a weight. Line shading with a third, diagonal shading to emphasise the darkest shadows. a) A copy of the original drawing at 2:1. b) Copy of the above drawing, reduced to 1:1. c) Medieval tap, line shaded, heavily faceted (1:1, r1:2). d) Medieval plaque; a flat sheet with raised decoration. (2:1, r1:1).

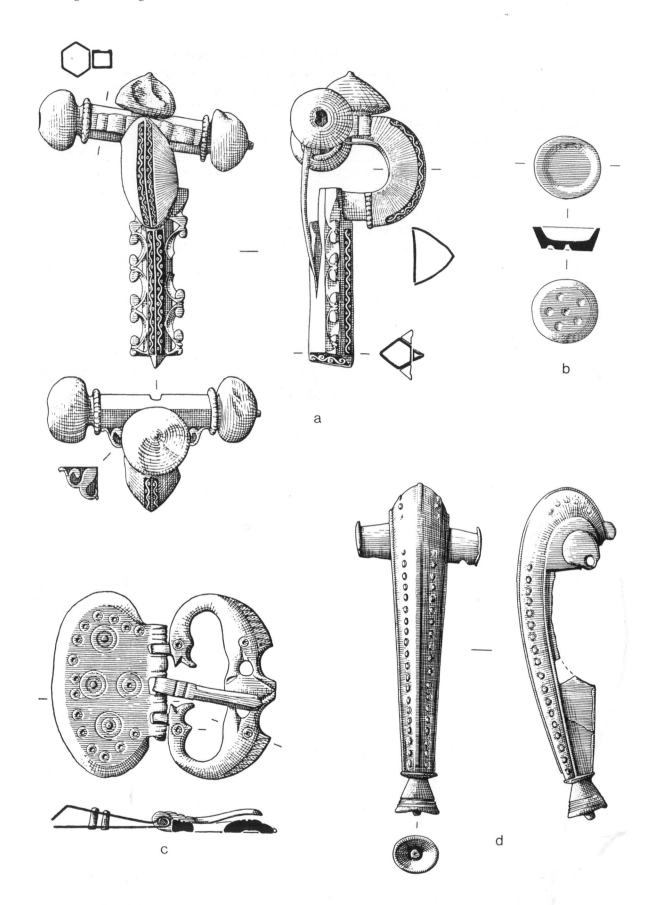

Fig. 12 Copper alloy objects a) Late Roman brooch with inlaid niello decoration along the curved bow and down the foot. This demonstrates the need for sections and detail views on a complicated object. (2:1,r1:1). b) Small medieval weight; front and back views and a cross section. (2:1, r1:1). c) Late Roman buckle decorated with fine incised line decoration and a smoothly curved loop in the form of a pair of dolphins. The cross-section shows the two rivets in elevation "behind" the line of the section. Note that the section is a composite of two sections at slightly different angles. (2:1, r1:1). d) Roman brooch. Note that the lines on the bow radiate to follow the curve of the brooch. (2:1, r1:1).

where horizontal lines represent the flat surface (with additional cross-hatching for shading) it is not easy to draw freehand parallel lines; illustrators who are right-handed find the lines have a tendency to drop down towards the right hand side. In this case it is worth drawing a series of horizontal pencil lines, about 10 mm. apart, to act as guide lines. These produce a visual guide and if a line drops slightly, the next one can be aligned by reference to the pencil lines. Such slight discrepancies give a more 'natural' look to the drawing. Where an object is broken or damaged a short continuation line can be used to show the original line of the object. If the shape of an object can be reconstructed accurately beyond the broken edges, this should be done with a dashed line.

When shading the darker parts of a drawing, care should be taken to prevent the shading becoming too dark. As stated above, stippling will run together, and cross-hatching will fill in if put too close together. Cross-hatching should be at the same spacing as the line shading; generally it is at right angles to the lighter tones, though on curved surfaces it should follow the curves, either round the edges or radiating down curved surfaces. Where a particularly dark shadow is required, a diagonal hatching can be added across the cross-hatching (Figs. 11, 12 and 13), but a fourth cross-hatching will almost always fill in and should be avoided.

Decoration on objects is usually incised or impressed, and can be shown by shading the shadow edge and leaving the highlit edges white. If the decoration is raised, the lighting is reversed so that the the left hand edges are lit, the right hand edges shaded (Figs. 11, 12 and 13).

Since all the different materials have to be depicted using the limited techniques described, the following section is intended merely to indicate how to approach different materials, with examples.

Copper and its alloys

Perhaps the most common ancient material for small objects, copper (and its alloys, bronze, brass, etc.), tends to have a smooth, even surface, which is yellowish when new and usually takes on a green patina after burial in the ground. Unless there is evidence that the patina was deliberately induced, the colour should be ignored. The surface should be shown as smooth, even when corroded, as the latter is not usually important, unless it hides decoration or some other feature (Figs. 11, 12 and 13).

Iron and steel

Although iron and steel are different in their make-up, they are normally illustrated in the same way. To distinguish the shading from copper alloy it is usually shown in a rougher, more random shading. When stippling iron, the corroded surface can be indicated with broken lines and patches of stipple based on the rough patches. See Fig. 14. Iron is often in a very fragile state, and sometimes so heavily corroded that the shape of the object can only be seen on an X-ray plate. The shape can be traced onto paper from the X-ray using a light box. If the surface of the particular object can be seen, the outline can be shaded accordingly. If not, it may be necessary to leave the shape as an outline.

Fig. 13 (overleaf) Copper alloy objects a) Roman candlestick showing line shading used to depict multiple curved surfaces. (2:1, r1:1). b) Roman bracelet; the front and side views depict the important hook area, including the beginnings of the decoration. The right hand view is 'unrolled' to show the complete sequence of decoration, to the half circumference point. In this case, this is sufficient, as, beyond this point, the design repeats symetrically. If the decoration did not repeat it would be necessary to draw out a complete "unrolled view". (2:1, r1:1).

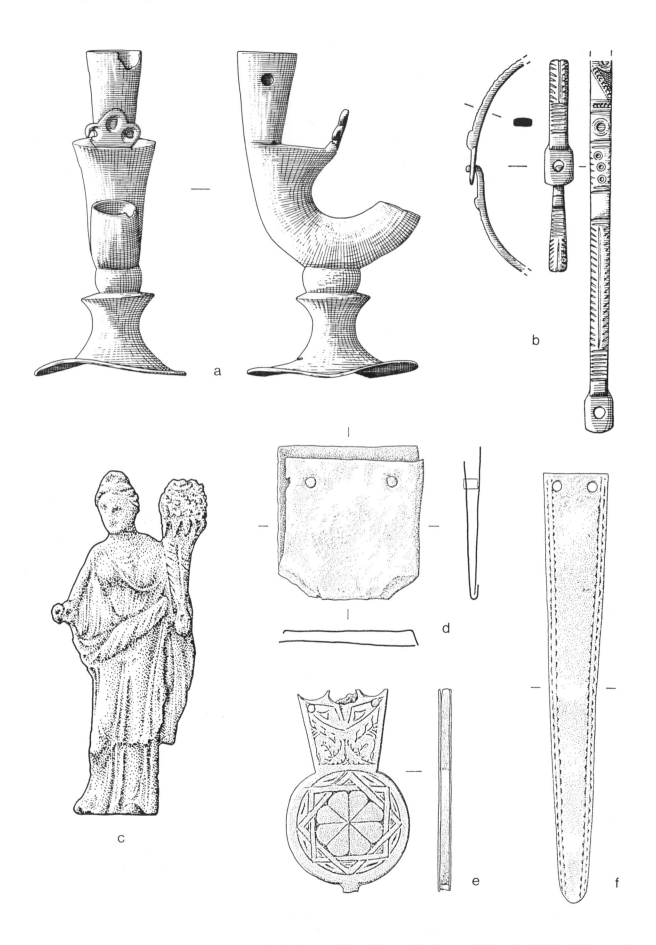

c) *Roman statuette. (Drawn at 1:1 for reproduction at either 1:1 or 1:2 (here at 1:1)). d) Medieval strap-end, illustrating the darkening of the backplate to 'throw forward' the front plate; also the depiction of folded and dented sheet. (2:1, r1:1). e) Medieval strap-end; showing the depiction of fine line decoration by stippled shadow-edges. (2:1, r1:1). f) Medieval strap-end, showing the use of light and dark shading to suggest folds in the sheet (2:1, r1:1).*

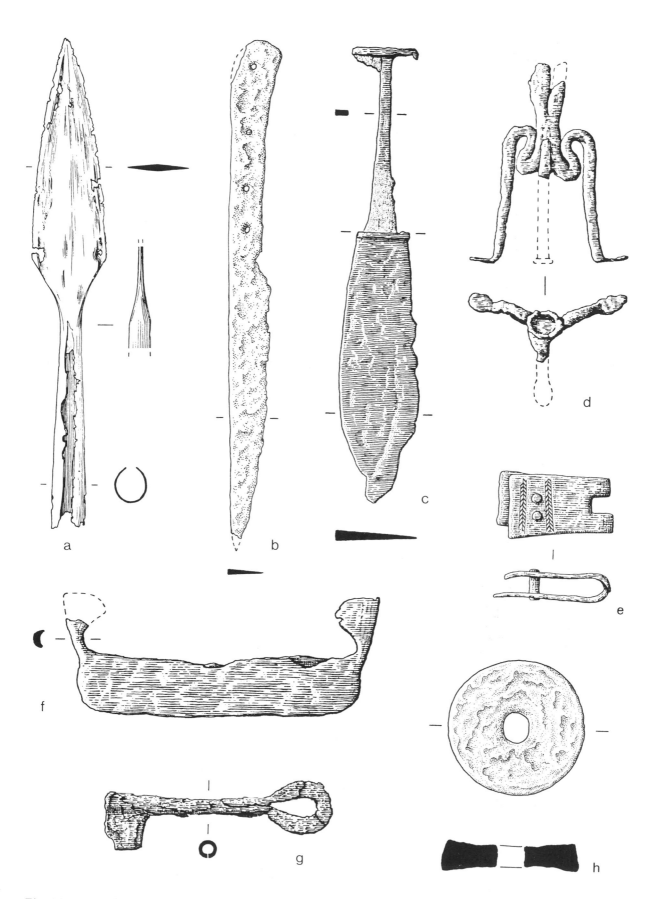

Fig. 14 Iron and steel objects. a) Medieval spearhead, with simple line-shading, using the lines visible in the surface. Note detail side view and sections. (1:1, r1:2). b) Medieval knife showing highly corroded surface. (1:1, r1:2). c) Late Roman knife with traces of the wooden handle in the corrosion. (1:1, r1:2). d) Roman candlestick, partially reconstructed. (1:1, r1:2). e) Medieval buckle plate with inlaid copper and brass strip. (2:1, r1:1). f) Roman 'shoe' for a wooden spade. (1:1, r1:2). g) Medieval key, very heavily corroded and cracked. (1:1, r1:2). h) Roman 'washer'. (1:1, reproduced here at 1:1 pen sizes 0.2 outline, 0.15 for shading.)

Lead, pewter and tin

Although not the same material, when new all have a similar silver-grey appearance. They can be depicted with stippling, similar to copper alloy, or with line; in the case of lead, the lines should be drawn rather irregularly to give the impression of the rough surface. Pewter is often used for badges with very fine decoration; these can be depicted with stippling, picking out the shadows (Fig. 15).

Fig. 15 Pewter, tin and lead objects. a) Medieval pewter badge. (2:1, r1:1). b) Roman lead handle with detail back view. (1:1, r1:2). c) and d) Roman lead discs; d) has stippling added to the line of shading of c). Both 1:1

Fig. 16 Gold and silver objects a) Medieval gold ring with stone setting. (1:1 reproduced here at 1:1).
b) Medieval silver head. Very fine shading, using 0.2 pen for outlines and 0.1 for shading, to depict the subtle
shapes of thin silver sheet, with fine punched decoration. (Drawn at 2:1, reproduced here at 2:1) c) Roman silver
ring, line shaded to depict the shiny surface. (2:1, r1:1). d) Medieval silver ring; light stipple to show worn, matt,
surface. Note 'unrolled' view to show full decoration. (Drawn at 1:1, reproduced here at 1:1)

Gold and silver

The two most common precious metals; as both are normally highly polished, they are best depicted with fine lines following the smooth shape of the object (Fig. 16).

Glass

Small objects of glass include pins, beads, counters, etc. Some coloured glass is opaque and has a matt surface; this can be illustrated with stippling. More polished glass objects are usually shown with fine lines. The colour of the glass is not depicted unless it is an added colour inlay. The colours of glass are otherwise described in the text (Fig. 17).

Stone

Stone comes in a wide variety of textures from very fine polished surfaces, through smooth matt surfaces such as slate, to very coarse grained sandstones and limestones. Stippling lends itself best to the coarser grained stones, while line shading can be used to show more polished surfaces; the smooth matt surface of slate can be shown by close stippling (Figs. 18 and 19).

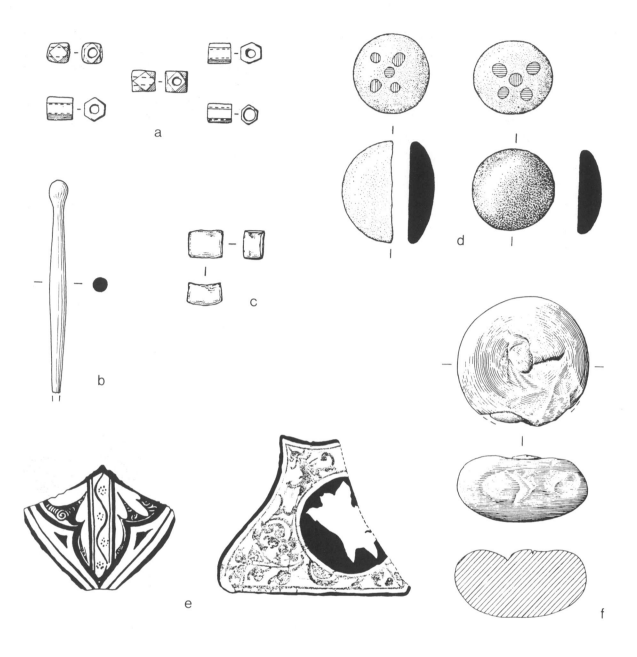

Fig 17 Glass objects a) Roman glass beads, no attempt to depict colour, but the perforation is shown by a dashed line. (2:1, r1:1). b) Roman glass pin. Simple line shading. (2:1, r1:1). c) Roman "tessera" or cube for mosaic work. Although dark blue, no attempt is made to show colour. (2:1, r1:1). d) Roman glass gaming counters; the two top, and the lower left are off-white; the lower right, is black. Stipple is used to show the nature of the worn, matt surface. Note the conventional representation of red and blue inlaid spots of the top two. (2:1, r1:1). e) Medieval painted window glass. The glass itself is left white, and solid black is used to indicate the painted areas; where two or more colours are involved, as in the right hand example, stippling is used to depict the lighter colour(s) and black for the darkest. The dashed line is a convention (not universal) for a broken, i.e. damaged edge, as opposed to an edge deliberately broken to a desired shape. (1:1, r1:2). f) Medieval "callender" or linen smoother; line shading to indicate surface of such objects. A side view and a cross section are both necessary to supply the full information. (1:1, r1:2).

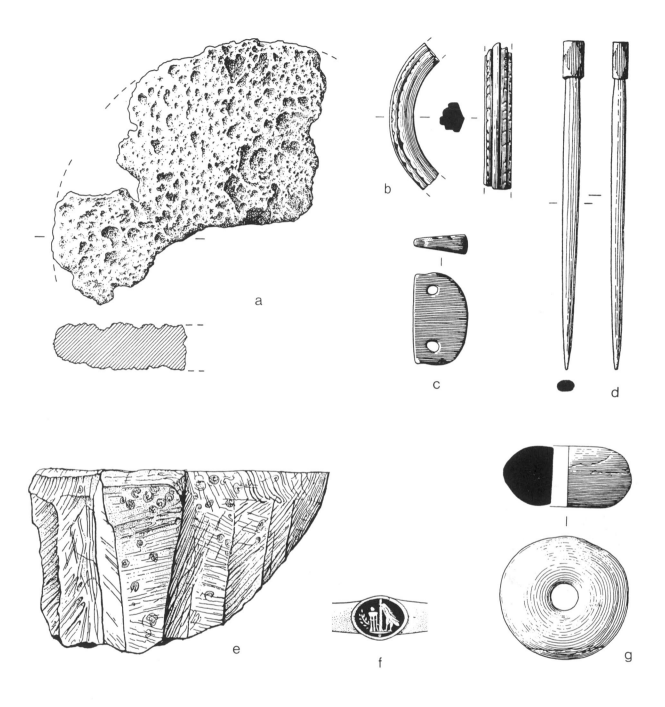

Fig. 18 Stone objects. a) Medieval quern stone of very coarse limestone, a combination of line and stipple to depict the very uneven surface. (Drawn at 1:2, reproduced here at 1:4; outline pen size 0.4, shading 0.3). b) Roman bracelet of shale, with a shiny surface. (2:1, r1:1). c) Roman segment from jet necklace with very highly polished surfaces. (2:1, r1:1). d) Roman jet pin. (2:1, r1:1). e) Medieval mortar of 'Purbeck marble', containing very distinctive fossils, and worked into shape with hollow vertical grooves; tooling marks left over the surface. A combination of line and stipple. (1:1, r1:2; drawn using pen size 0.4 for outline, 0.3 for shading). f) Roman intaglio from a ring; gemstone depicted black with the design left white, and a lightly stippled band to denote a vertical grey band in the stone. (2:1, r1:1). g) Roman shale spindle-whorl, damaged and lacking its shiny surface. Treated similarly to b) but with a less polished look. Note the division of the side view into a half-section to show the perforation. (2:1, r1:1).

Fig. 19 Stone objects. a) Medieval quern stone with a grooved surface. Drawn at 1:2, reduced to 1:4. Outline drawn with 0.4 pen, shading with 0.3. b) An unfinished ?hammer of a chalk-type stone. Fairly coarse open stipple. (1:1, r1:2; outline and shading both 0.3). c) Medieval whetstone. Finer stippling to indicate the fine grain of a schist-type stone. (1:1, r1:2). d) A damaged prehistoric polished stone axe. Line shading to depict the polished surface. (Drawn at 1:2, reproduced at 1:2. Outline 0.2, shading 0.15). e) Tudor carved slate. Fine stippling to show the subtle shapes of the sculpture, coarser shading to show areas of damage. (1:1, r1:2).

Ceramic objects

A wide variety of objects fall under this heading; clay and pipeclay figurines, bricks and tiles, etc. The drawings are normally stippled for fine grained figurines and small objects; no attempt is made to depict the colour of the clay. If to be drawn, Roman tiles are treated as objects; if the tiles are stamped or patterned, the design is drawn out in solid black, this representing the letter or raised portions of the pattern (Fig. 20).

An exception to the general rule of shading objects and tiles is the illustration of medieval floor tiles. Where they are of a single coloured glaze, they are normally stippled. When they are inlaid (the design was impressed with a stamp and then filled with white clay before glazing) the final effect is usually of a red-brown ground with a yellow design; the former is drawn as solid black, the inlaid design is left white. Areas where the surface has flaked away are normally stippled lightly. Post-medieval glazed tiles are normally treated in the same style as pottery.

Organic materials

Having been living organisms, these materials all have grain structure which can provide useful textures to aid the illustrator.

Bone, ivory, horn and antler

These materials have been used for many different artefacts over the centuries and occur amongst almost all groups of objects likely to need drawing. A simple rule with bone and horn is to use line shading when polished, and stipple when rough or unpolished. Bone objects frequently show the internal structure of the bone and this can be easily depicted with stipple. Antler has its own easily recognisable texture and stippling enables this to be rendered quite effectively. Ivory, when very highly polished, shows virtually no grain and can be represented with close stippling to show the smooth polished surface (Figs. 21 and 22).

Wood

Has a multitude of different textures and many can be used to show the nature of the object; it is usually drawn with line shading to bring out the grain effect, although certain woods, for example yew, have a surface texture that can be used to advantage (Fig. 23).

Leather

It is only recently that modern conservation methods have produced leather objects with all their texture and decoration clearly visible. The subtleties of leather, with its creases and folds, and grain texture provide much that can be used in a drawing. Stippling can be used to show the softness of leather; where an inner surface can be seen through a hole or where a surface is folded, this inner surface can be shaded rather more darkly, using a bigger pen size for the stippling. This helps project the front surface forward, and emphasises the space between the two surfaces. Decoration is often marked out with a blunt tool, making an indentation which can be shaded as a slightly darker hollow; sometimes it is scorched in with a hot iron, which is best depicted with a darker line. Incised decoration can be shown with a fine line for the shadow edge (Fig. 24).

Fig. 20 (overleaf) Ceramic objects. a) Roman lamp. Fine texture depicted with fine stipple. (1:1, r1:2). b) Roman pipe-clay figurine, very fine white fabric (2:1, r1:1). c) Roman tile; stamped with a roller pattern; the solid black indicates the identations in the tile, i.e. the raised sections of the roller stamp. (1:1, r1:2). Outline 0.3. d) Medieval floor tile with inlaid design. (1:1. r1:2; though usually reproduced at 1:3 or 1:4). e) 17th century clay pipe; light stippling to inidicate the fine texture and the subtle form of the bowl. Stamped makers mark from base drawn out alongside (1:1, reproduced here at 1:1; stamp drawn at 2:1; sometimes drawn at 1:1). f) Roman tile stamps. (1:1, r1:4) Outlines drawn with a 0.3 or 0.4 pen. The letter forms are drawn in a solid block irrespective of whether they are stamped into the tile or "stand-up" within a stamped frame.

Fig. 20 Ceramic objects

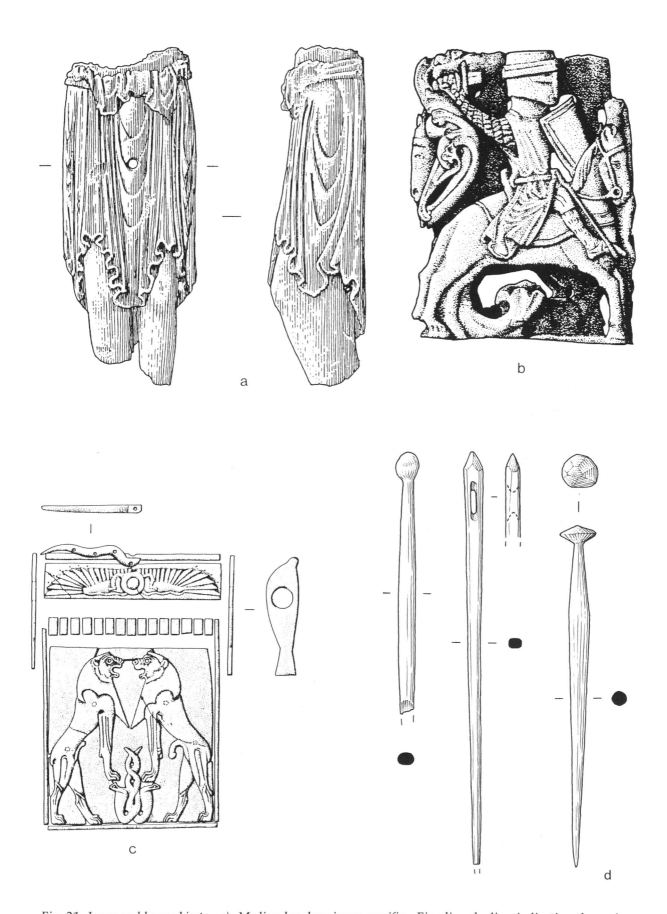

Fig. 21 Ivory and bone objects. a) Medieval walrus ivory crucifix. Fine line shading indicating the grainy texture (1:1, reproduced at 1:1; 0.2 outline; 0.1 shading). b) Medieval ivory chessman. Very polished outer surfaces, very rough (and dark) background (Drawn at 1:1, for reproduction at 1:1; 0.2 outline, 0.1 shading for figure; 0.2 shading for background). c) Egyptian ivory inlays for wooden box lid. Very highly polished surfaces indicated with fine stippling (Drawn at 1:1, here reproduced at 1:2; probable publication at 1:1. Outline 0.2, shading 0.1). d) Roman polished bone pins and needle. (2:1, r1:1).

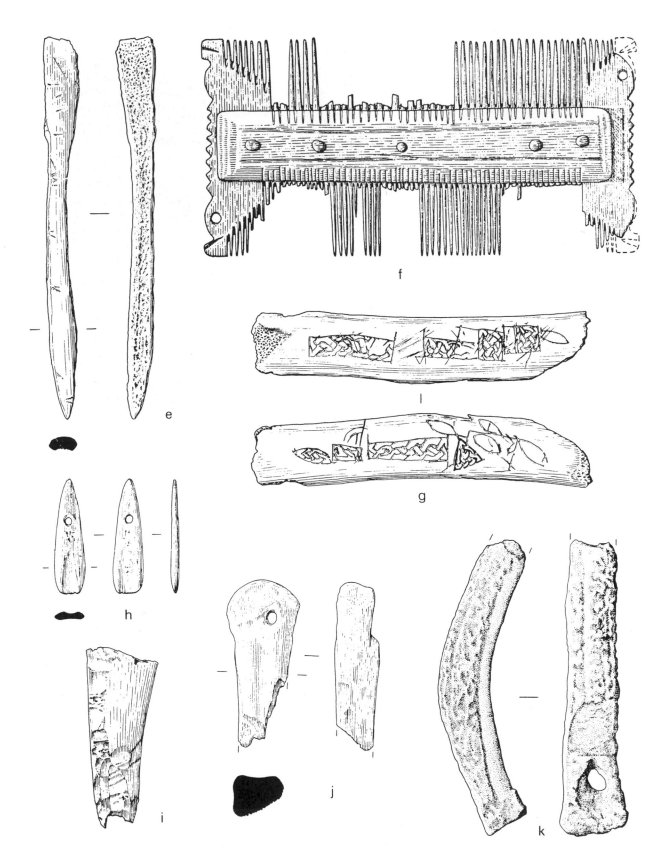

Fig. 22 Bone and antler objects. e) Medieval bone object, showing the polished outer surface (with fine cuts across the surface), and rough grain texture on the rear. A combination of line and stipple. (1:1. r1:2). f) Roman bone comb; line shading indicating the different grain direction of both sections and side plates, held together by iron rivets. The missing corners are restored with dashed lines, but not the missing teeth, as this would become very confused. (2:1, r1:1). g) Saxon artist's bone 'trial-piece'; some stippled grain texture at the ends, otherwise line shading of polished surfaces. Fine lines to show scratched decoration. (1:1, r1:2). h) Medieval bone tool, highly polished from use. (1:1, r1:2). i) Medieval bone fragment, line shaded, showing cut surfaces indicated simply by shading. (1:1, r1:2). j) Medieval worked bone; broken line shading depicting natural bone surface. (1:1, r1:2). k) Medieval antler object. Stippling used to show the natural surface texture of antler. (1:1, r1:2).

Fig. 23 Wooden objects. a) Roman wooden disc with central hole. Line shading following the pronounced grain texture, and slightly thickened to indicate the sloping shadow edges. (1:1, r1:2). b) Roman wooden peg, with polished surface. In this case there is little obvious grain texture, so the line shading really represents the form of the object and various small dents, etc. (1:1, r1:2). c) Medieval wooden "terminal". Lines following both the form and the grain, and the very noticeable cracks along the grain. The vertical cross-section is necessary to show the true dimensions and contours of the object. (1:1, r1:2). d) Roman rope fragment, made from three strands of bark twisted together. Line shading following the grain texture of the strands. (1:1, r1:2). e) Roman basket made from woven willow strands. A very linear treatment, the shading is minimal, and relies on the dark areas of the back showing through. (Drawn at 1:1, reduced to 1:4; pens, 0.5 outlines, 0.35 shading).

Fig. 24 Leather objects. Leather scabbard and belt of medieval date. Both drawn at 1:1 and reproduced at 1:2. The scabbard shows the use of stippling to indicate a worn, smooth surface, with decoration, impressed into the surface and faint in places. The internal surfaces where visible are shown slightly darker. The belt fragment shows some fine creasing and also designs punched with a sharp metal tool.

Combinations of materials (including inlays, coatings and colours)

Where materials occur in combination, the usual styles should be used; it may be necessary to emphasise one material or another. Fig. 25 shows some examples of combined materials.

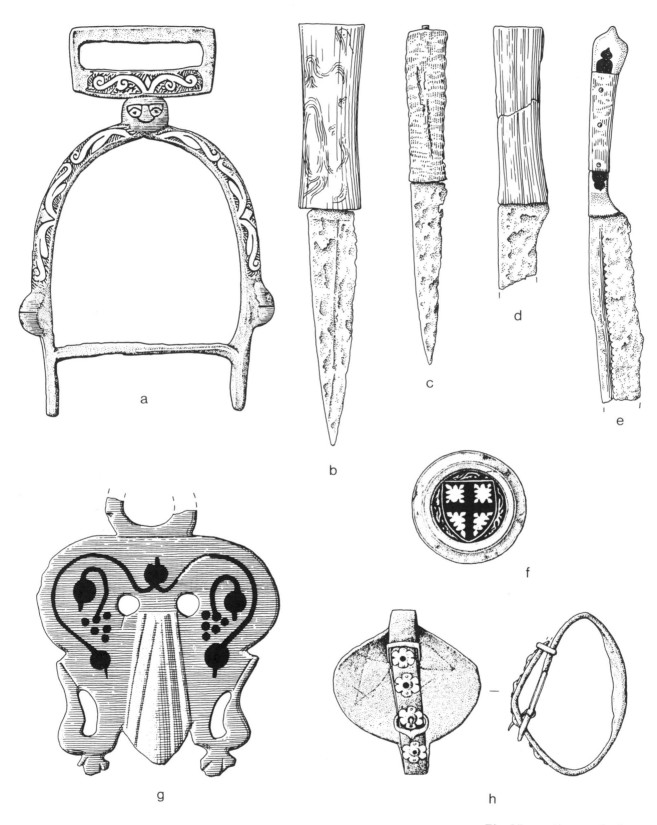

Fig. 25: caption overleaf

Whereas decoration can be shown as part of the general shading, a different problem arises with inlays, coatings and colours. Inlays can be of several types; metal inlays in metal objects can be shown as simple outlined marks, e.g. copper cutlers' marks inlaid into iron knife blades; niello, a black sulphur-based compound, is often used on Roman objects, and is usually drawn in solid black to show the effect of the design on the object. When makers' marks or names are inlaid into an object, they are usually drawn out alongside the object drawing, at a scale which will publish them at actual size, e.g. the mark on a knife; the knife would be drawn at 1:1 for reduction to 1:2; the mark would be drawn at 2:1 for reduction to 1:1. If the inlay or mark has fallen out, the 'hole' is shown within the shading as a hollow. Coatings such as gilding or silvering are frequently encountered; if the coating is only partially preserved, it is often omitted and described in the text. If it forms a pattern that can still be made out, it can be indicated by a lighter version of the shading.

Where an object contains areas of coloured enamel or other coloured substance it is depicted using a set of established conventions slightly modified from those originally devised in the 17th century to record heraldic coats of arms, in black and white. The colours are indicated with patterns of lines or dots. Unlike shading lines, these lines are ruled, and it is usually advisable to use a slightly thicker line weight. This helps to emphasise the area of colour. The spacing of the lines can be used to indicate the shade of colour; more widely spaced lines indicate a paler shade, more closely spaced lines indicate a darker shade. It should be noted that the conventions for gold and silver are used to represent yellow and white respectively, apart from items of heraldic metalwork where they represent gold and silver. These conventions are not used to indicate gilding or silvering as a coating (Fig. 26), but only where the gilding was applied to specific areas to form a medieval heraldry, they cover the colours used on enamelled or painted heraldic objects, e.g. pendants. Including gold and silver, there are seven colours, but occasionally other colours appear and the conventions can be added to as necessary. Objects of other periods can be treated the same way; some Roman brooches have panels of coloured enamel. Where several colours appear together, or more than one object is illustrated, it may be worth including a small key to the colours; this is essential if conventions have been 'invented' for the particular illustration. It should be noted that the colour conventions used for ceramics are different, see p.75.

Fig. 25 (Previous page) Combinations of materials and inlays. a) Viking iron stirrup; the iron is represented by the stippling, copper inlays are shown with solid, black lines and brass inlays by white areas and lines. (1:1, r1:2). b) Medieval iron knife with a wooden handle, polished wood with a natural 'figured' grain. (1:1, r1:2). c) Medieval iron knife with a coarse grained wooden handle. (1:1, r1:2). d) Medieval iron knife with a handle of straight grained ?fir-wood, a very prominent grain. (1:1, r1:2). e) Medieval iron knife with an inlay of different iron or steel in the blade; the wooden handle is completed with a shoulder plate (at the base of the handle) and an end-cap (at the top) of silver; both are inlaid with a shaped piece of dark horn. Five different materials in all, requiring the use of both line and stipple in different combinations. (1:1, r1:2). f) Medieval plaque; copper alloy with a central disc, decorated with black enamel and silver, shown as naturally as possible. (1:1, r1:2). g) Roman harness pendant of copper alloy with a black niello inlay. Note a small section of inlay is missing, leaving only a groove. The lower central part of the pendant is facetted and therefore drawn with highlit areas and cross-hatched shadows, unlike the flat areas of the pendant. (2:1, r1:1). h) Medieval archer's bracer or wrist-guard. Leather with copper alloy buckle and decorative fittings. Two densities of stippling provide the contrast between the dark leather and the bright metal fittings. Note also the faintly incised "bow and arrow" design on the leather. (1:1, r1:2).

Fig. 26 Colour conventions. This figure indicates those that are generally accepted; others may be invented as necessary to deal with extra colours, e.g. brown. a) Medieval harness pendant, with coloured coat of arms on both faces, silver and red on the left, gold and blue on the right. In this case the colours are so well preserved that they take priority over shading conventions. (2:1, r1:1). b) Medieval harness pendant with traces of enamel (blue). The ruled, closer-spaced, lines of the enamel stand out from the general line shading. (2:1, r1:1).

Textiles (Figs. 27 and 28)

Before starting to draw textiles it is important to get a diagram of what the specialist requires, as they are often difficult to interpret unless you are very experienced. They are not illustrated in the same way as other finds, but instead are plotted out on graph paper to show the exact placement of stitches and direction of weave. They are often enlarged and should

a) Stitching (after Hald, 1980, p.281, fig. 285)

b) Sewing (after Hald, 1980, p. 281, fig. 291)

c) and d) Twill depicted in black and white

e) A line shaded illustration of twill, showing the selvedge on the right and number of stitches used in each block in the margin.

Fig. 27a - e Textiles (not to scale). c - h after Walton and Eastwood 1988

f) A "naturalistic" depiction of a woven fabic - showing the direction of the warp and weft.

g) A "semi-naturalistic" representation of 'f'.

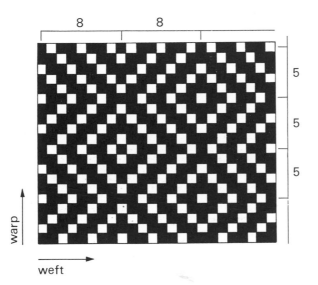

h) A method of depicting warp and weft threads using black and white squares (black represents a warp crossing over a weft thread and white represents weft over warp).

Fig . 27f - h Textiles (not to scale)

have an indication of the stitch size or an actual scale next to them, but this is not always possible, especially when dealing with silks and other very fine materials. It is always advisable to write down the measurements of any repeated pattern alongside the relevant drawing.

The whole piece is not usually drawn when a pattern repeats itself, but just enough to show one complete section. The weft is always horizontal and the warp vertical (Figs. 27f-h) and the selvedge is usually shown on the right hand side (Fig. 27e); however, it can be shown on either side.

Some illustrations have line shading on each thread to show the way in which they were spun, but this is very time consuming and not absolutely necessary (Fig. 27e). Some excellent examples of this style can be seen in "Die Textil-und Schnurreste aus der Frühgeschichtlichen Wurt Elisenhof" by H. J. Hundt (1981). Naturalistic (Fig. 27f) or semi-naturalistic representations (Fig. 27g) without shading can be made. Examples of these can be found in "A Brief Guide to the Cataloguing of Archaeological Textiles" by Penelope Walton and Gillian Eastwood (1988).

a b

Fig. 28 Printed textiles; (not to scale)
a) A black and white illustration of patterned fabric. (After Schmedding [1978] page 206, Kat. Nr.191.)
b) A lined drawing of patterned fabric. (After Schmedding [1978] page 103, Kat. Nr. 98.)

Stitching and sewing are depicted by outline alone (Figs. 27a and b) and patterned weaves like twill can be depicted in black and white (Figs. 27d and h). Figs. 27c and d show only the weft side of the fabric, usually both are illustrated and can be represented by squares (see Fig. 27h). Illustrations like these can be seen in "Ancient Danish Textiles from Bogs and Burials" by Margrethe Hald.

When a pattern repeats itself but is irregular, as in Fig. 27e, the number of threads which go to make up each section should be indicated on both the weft and the warp sides of the cloth. If a fabric has an elaborate print, this will be drawn separately, either as a black and white drawing or in line (see Figs. 28 a and b).

Technical Terms used above :

'Selvedge' - The side edges of the textile where the weft turns back.

'Warp' - The system of threads which runs vertically or from back to front.

'Weft' - The system of threads which runs horizontally or from side to side on the loom.

The illustration of ceramic vessels

In this chapter the standard conventions used to draw pottery are described. The same basic principles can also be applied to the illustration of glass and certain other cylindrical artefacts. The methods used here are not universally applied but have been developed over a number of years to form a standardised system suitable for the illustration of many different types of pottery. It is designed to convey as much detail as possible about the shape, size, decoration and methods of manufacture.

Specialist materials

There are a number of pieces of specialised equipment necessary for the illustration of ceramics. Unfortunately these are not all readily available in the shops and those which can be bought are often difficult to find.

Tools which can only be made by hand are : radius cards and charts, weighted boxes.

Tools which can be bought from hardware stores, etc. are : calipers, profile gauges, compass with blade attachment and engineer's squares. The latter can also be made cheaply and effectively by hand.

The radius chart (Fig. 29)

What is it? As its name suggests, this piece of equipment can be used to measure the radius of the rim, base and occasionally the body of a complete vessel or sherd. It simply consists of a series of concentric circles of known radius drawn out on any material which can be laid flat on the work surface. Any horizontal such as the rim or base of the pot can be matched to the nearest circle, and the radius noted. This is particularly useful for reconstruction drawing.

How to make one : this is made by taking a square piece of card or perspex, placing the point of the compass in the centre and drawing a series of concentric circles, each 5 mm. apart. The size of the card or perspex will depend on the largest circle or radius required, and this in turn will depend on the radius of the largest pots to be drawn.

Probably most useful is one of about 30 cms. sq. with the smallest circle 2.5 cms. radius, the largest 15 cms. radius; occasionally a larger one is needed, for example 60 cms. square, with smallest circle 2.5 cms. radius and largest 30 cms radius. If using perspex, wash it well with soapy water and dry it off before starting to draw the circles.

Use a compass with an ink nib or pen attachment and put the point of it in the centre of the square; mark this with a dot so that it is easy to relocate the compass point. Each time the circle is complete, extend the compass another 5 mm. and draw the next. Leave a gap in each circle or erase a band (of approx. 1 cm. width) from the centre point out to the edge of the square and mark the radius of each circle in the space. The ink will flake off the surface of the perspex unless it is covered, for example with self-adhesive book covering film.

Cut this about 5 cms. wider than the radius chart and cut a 5 cms. sq. out of each corner, fold over and stick. If this edge is sealed with "Magic Tape", the chart should last for years.

Radius charts can be made from packs of circular graph paper bought from stationery shops by simply marking the radius of each thickly lined circle, usually about 5 mm. or 1 cm. apart but these are not as useful or as hard wearing as perspex ones.

It is now possible to make your original chart on cartridge paper and have this photocopied onto card and then laminated so that the original can be kept and new copies made when needed. If a transparent chart is required, transparent photocopies can be made and then stuck onto perspex (Adkins 1985). The latter is expensive, but perspex charts have proved to be the most hard wearing and easiest to use when measuring the bases of plates, bowls, dishes and any other vessels where the rim is much wider than the base or vice versa.

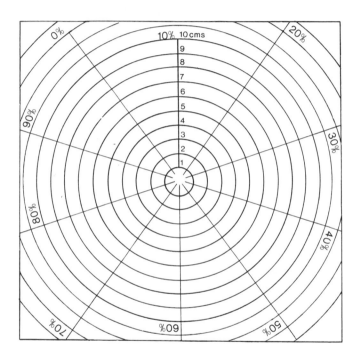

Fig. 29 A radius chart (not to scale).

Estimated vessel equivalents – EVES.

Many archaeologists/ceramicists measure 'EVES', or estimated vessel equivalents, as a corollary to the weight of the pottery groups. This is a measurement of the % of a rim or base sherd left surviving. This is done on a rim chart which has been divided into segments of 10%. To do this draw a line from the centre to the edge of the largest circle, and placing a protractor on the central compass point mark and the base on the line, measure off 36° and draw another line. Move the base of the protractor onto this line and repeat until you reach the first line again. Mark the first line 0; this will also be 100%, and add 10% for each until you reach 0 again. If a base or rim sherd is placed on the curve it fits best with one of the broken edges at 0, the percentage can be estimated by how close the other end is to any of the other percentage marks (Fig. 30).

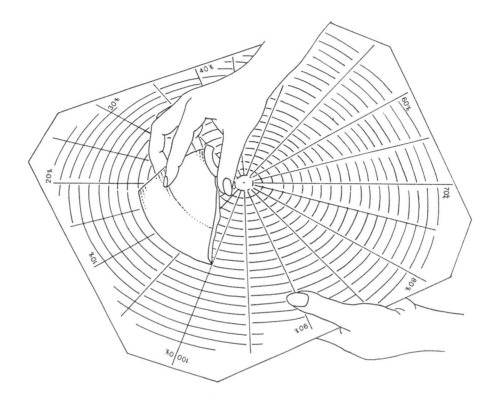

Fig. 30 Using the radius chart to find out the radius and percentage of the rim present.

Radius cards (Figs. 31 and 32)

Radius cards are used to measure the radius of sherds of pottery. They can be fitted into the curve of horizontal wheel-thrown lines in order to estimate the radius of the vessel at that point.

This is particularly useful when reconstructing the band of the original vessel from which the body sherd came.

How to make it: take a large piece of white plasticard, which can be bought from model shops, and draw 3 vertical lines each 5.5 cms. apart. Join them together at the bottom by a horizontal line, then draw a series of horizontal lines at 1.5 and 5.5 cms. alternately. Place the point of the compass in the middle of the lowest 1.5 cm. horizontal line, where the central vertical line bisects it, and draw a curve of 2.5 cms. radius, starting and finishing on the 1.5 cm. line. This should fit in between that line and the one above so that the top of the arc is at least 1 cm. below it. Move the point of the compass up the central vertical line so that the next arc will fit in between the next 1.5 and 5.5 cm. lines. Repeat this process and increase the radius by 0.5 cms. each time until you reach 30 cms. The size of the largest curve will depend on the largest radii likely to need measuring. This will change from one group of pottery to another. Rub out the 1.5 cm. line in the area of each curve and erase the central vertical line. Cut along all the remaining straight lines using a steel rule and scalpel or Stanley knife. Use

sharp scissors, a scalpel, or a compass with a blade attachment for the curved areas. For each radius there will be two cards (Fig. 31), one with a concave and one with a convex curve. These can then be placed at right angles to the internal and external wheelthrown lines on a sherd respectively, in order to gauge the radius at that point (Fig. 32).

Special equipment which can be bought in hardware and modelling shops includes calipers for measuring the thickness and distance between vessel walls, and a profile gauge which can be gently eased into the edge of the more robust and less fragile vessels to give an approximation of their profile. This cannot be relied on alone to be a truly accurate representation of a profile, but provides an instant outline which can then be made more accurate later.

Fig. 31 Two radius cards.

Fig. 32 A radius card in use.

Fig. 33 Engineer's squares. a) A metal engineer's square, with a built in spirit level. b) An engineer's square made by taping two set squares together. c) and d) An engineer's square made by attaching a weighted box to a set square.

Engineer's squares (Fig. 33)

These consist of a free-standing right angle which can be placed on the paper next to the object and used to project down at 90° from the edge of the object in order to get an accurate outline.

Metal engineer's squares, with spirit levels and a detachable upright ruler (Fig. 33a), can be bought from a number of hardware stores. Plastic ones, with a pencil or lead attached so that the point of the pencil corresponds with that of the 90° angle, can also be bought or made. Leadless versions can be made taping two set squares of the same size together along one of the 90° axis (Fig. 33b) or by attaching a weighted box to the 90° angle of a set square (Figs. 33c and 33d).

A weighted rectangular box

This is used to align the base or rim to the horizontal axis of the page. It can be made by sticking or nailing together pieces of wood with 90° angles to make an open-topped box. Fill this with sand or stones to weight it.

Standard conventions and the drawing process

Ceramics are normally only drawn if their fabric type, shape and decoration cannot be matched with any of the ceramics already drawn. It is advisable to keep a quarter-sized photocopy of each illustration glued to a record card (Fig. 34), as this will provide a quick and ready reference to what you have already drawn. The corpus card is designed to give information on the type of pottery, i.e. where it was made, its fabric and form, whether it was found on an excavation or in a museum or private collection. If the vessel was found on an excavation, the site code/name, the date of the excavation and the context are all recorded, but if on display, in the reserve collection of a museum or a private collection, the name of the museum or collection and an accession number should be noted. Each card is given a number, starting with 1, and is then catalogued according to its fabric type or source, i.e. "London type ware", then its form, i.e. "cooking pot", and within this category is then arranged in numerical order. If a vessel is paralleled with one already drawn, then it is only necessary to record the number of the previous card and not to draw it (Tyers & Vince, 1983).

Standard conventions

Most ceramics are illustrated at 1:1 for reduction on the final page to 1:4. However, certain adjustments will have to be made for very large or small vessels which may have to be drawn at smaller and larger scales respectively. Stamp bosses and other small details are often drawn at 2:1. They are always shaded as if the light were coming from the top left. All shading is produced by line, broken line, varying densities of stipple, or combinations of these. All ceramic vessels are drawn in profile and then split into two halves down the centre of the body of the pot. The right hand side normally shows any external detail and the left only internal detail. This rule holds true for Europe and a number of other countries, while the reverse is true in parts of America.

Ceramic vessels and other hollow, spherical, cylindrical or cone-shaped vessels are drawn using a system of orthographic projection which includes elevations, sections and plans. The elevation is the view which is normally drawn first and may be the only one required. This is the view taken when the pot is lying on its side as if it had been cut in half through the handle, placed flat down on the page and drawn around. At one time this method was actually used, despite being rather destructive! Now the pot is positioned on the paper and its outline drawn by projecting down from its outer edge at 90° to the paper.

Initial measurements

Measure the radius of the base and rim of the pot on the rim chart. To do this simply place the rim chart on a flat surface, then hold the rim of the complete vessel or sherd as close to the chart as possible, so that no light can be seen coming between the two. Match the curvature of the rim to the circle it fits best and read off its radius (Fig. 30).

Common Name	Form Name	Corpus No.
LONDON TYPE WARE	AQUAMANILE	22185

Illustration and scale 1/4	Fabric codes 2926	
	Site	Context
	ER No	Acc No BM 1915,12-8.
	Description AQUAMANILE IN SHAPE OF A RAM – WHEEL THROWN BODY ONLY.	
	Dating 13TH CENTURY	
	Bibliography PEARCE ET AL 'LONDON-TYPE WARE' (1985)	
MOL POTTERY CORPUS CARD MUS 5123	Recorder MJJ	Date 22·10·82

Fig. 34 *A record card with a 1/4 sized photocopy of an "aquamanile" (water holder) stuck onto it.*

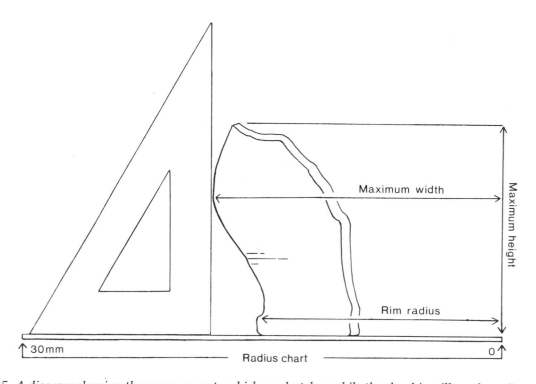

Fig. 35 *A diagram showing the measurements which can be taken while the sherd is still on the radius chart.*

57

Fig. 36 Measuring the height of a vessel while it stands on the radius chart.

The maximum girth of a complete pot or the widest part of a sherd can also be measured on the rim chart by placing the rim or base on the curve it fits best and projecting down from the widest part with an engineer's square (Fig. 35). Measure the height while the vessel or sherd is either standing squarely or inverted on the chart (Figs. 35 and 36). When a pot is complete, many of these measurements can be taken using dividers with the points kept on the same horizontal plane as the horizontal axis of the paper (Fig. 37).

Drawing an initial framework (Fig. 38)

Draw a straight, horizontal line with the T-square and, holding a set square against it, draw a vertical line at right angles to it. Allow enough room on either side for the maximum width of the vessel to fit on the paper. There will now be a 'T' shape if drawing a base sherd. Make a mark on the vertical to indicate the height of the vessel or sherd, slide the T-square to this

point and draw another horizontal line parallel to the first. Measure out from either side of the centre line and mark the radius of the rim or top of the vessel or sherd. Do the same for the base or bottom and for the maximum girth.

This has now produced a framework in which to draw the pot.

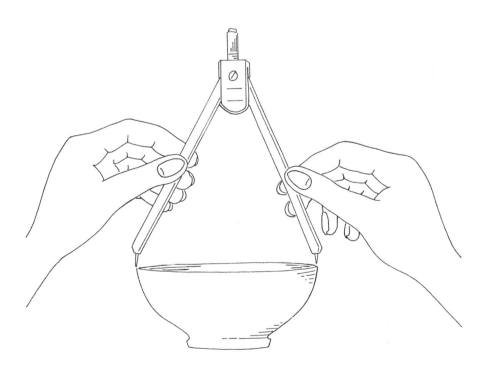

Fig. 37 Using dividers to measure the diameter of rims and bases on complete pots.

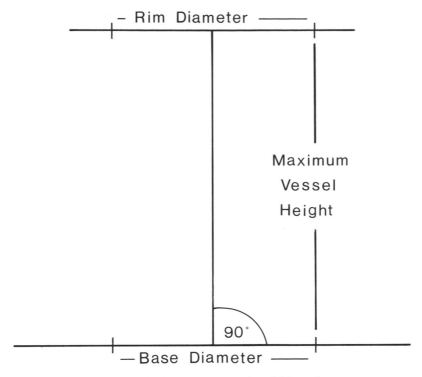

Fig. 38 A framework of measurements in which to draw your pots.

Drawing a complete vessel

Rest the pot on its side so that the base, and if possible the rim, lie along the correct lines and that the edge of the rim and base are immediately above the radius marks. Any spout or lip should be on the left and the handle on the right. This can be done by hand, but to ensure a correct orientation it is advisable to align a weighted square box with the lowermost horizontal line. The base of the pot should be held flat against this and can be stuck to it with white plasticine. It can also be secured to the page with plasticine, but this will leave greasy marks on the paper unless a piece of card or thick paper is placed between it and the page. When in the correct position use an engineer's square to project down from the sides of the pot onto the paper, and draw round the outline. Sometimes it is only necessary to draw one side of the vessel in this way as the other side can be traced, if symmetrical in shape. If used carefully a toothcomb can be used to estimate the shape of the vessel (Fig. 39a). Using the calipers, measure the width of the vessel wall and indicate this on the left hand side of the illustration (Fig. 39b). Draw any distinguishing features which occur on the inside of the pot on the left hand side of the central dividing line, and any external features on the right hand side.

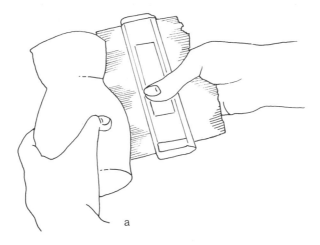

Fig. 39 a) Using a profile gauge to estimate the shape.

Fig. 39 b) Using calipers to measure the thickness of the wall.

Drawing sherds

If a sherd is small and has either no rim or base, or not enough to get an accurate measurement of its radius, it is drawn in outline with its internal surface facing the page. It is normally the external surface which is decorated, so this is the one which is usually depicted. Its section is drawn to the left and a short horizontal line is often placed between them to indicate that they are two views of the same object (Fig. 40d and e). Where possible, the sherd should be orientated on the page at the angle it might have had on the original vessel.

The section should be orientated in the same way with the external surface to the left and its internal surface to the right. To ensure that both views are the same length, a horizontal pencil line can be drawn across the top and bottom and the two views should fit between these exactly.

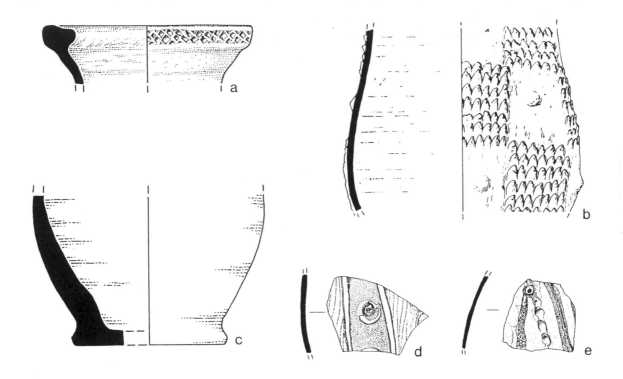

Fig. 40 Illustrations of sherds. (1:1, r1:4). a) Reconstructions of the rim from a single rim sherd. b) Reconstructions of the body from a single body sherd. c) Reconstructions of the base from a single base sherd. d) and e) Illustration of single sherds which were too small to reconstruct the band of the pot that they came from.

Reconstruction

Single sherds

If the body/rim or base of the sherd is large enough to measure its radius, the band on the complete pot from which it originated can be reconstructed (Fig. 40a, b and c). Measure rims and bases on the rim chart and place radius cards along horizontal wheelthrown or smoothing marks to estimate the radius. A framework of one vertical line and several horizontal lines of the required radius can be drawn and the sherd fitted into it. The outline can be drawn on one side of the vertical line and then traced over to the other side. Wherever it is unclear what form a pot takes at its broken edge, draw a dash of about 8 mm., 4 mm. away from the break and also on the central vertical line to show the direction the outline would have continued in when complete.

If the artist is familiar with the type of pottery he/she is dealing with and is convinced of its original form, the single sherd reconstruction can be extended using broken lines (of about 2 mm. in length and 2 mm. apart) to indicate the outline the vessel may have had when complete (Fig. 41).

A number of sherds

Occasionally a number of base, body and/or rim sherds from the same vessel may be used to reconstruct the outline of the whole pot, even though they themselves cannot be stuck together to form a complete profile (Fig. 42). (First, of course, it is necessary to look at the fabric and form to see if the sherds look as if they all originate from the same vessel.)

Do a reconstruction drawing for each sherd, as above, on tracing paper. Draw a central vertical line on a piece of cartridge paper and place the centre lines of each of the sherd drawings one above the other on this line. Slide them up and down the line until the most probable combination is reached. A knowledge of the most likely shapes and forms of certain types of pot will help in this, but can only be gained by experience.

Join the separate outlines together with dashed lines.

Some archaeologists prefer to have any sherds which make up the surviving piece of ceramic drawn in outline (Fig. 43), even though they may all be stuck together to form one large piece at the time of drawing. This is the usual method for illustrating prehistoric and Iron Age pottery, which is often composed of several sherds and seldom complete.

Here the pot is drawn as for the 'single sherd' and where possible 'the single sherd

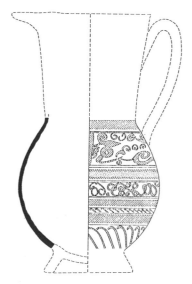

Fig. 41 Two examples of sherd reconstructions from known vessel types which have been dashed in outline (1:1, r1:4).

Fig. 42 A reconstruction of several sherds of the same vessel (1:1, r1:4).

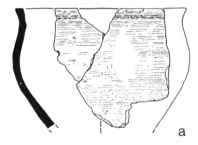

Fig. 43 Prehistoric pottery showing the composite sherds in outline.
a) Burnished sherds extending over the centre line.
b) A rim sherd with nail impression.
c) A base sherd (1:1, r1:4).

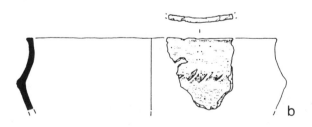

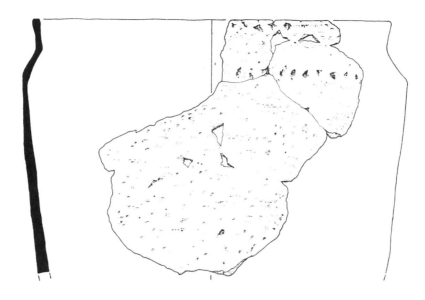

Fig. 44 Prehistoric pottery extending across the centre line (1:1, r1:4).

reconstruction', but the outlines of each sherd are placed to the right of the centre line along with any external modifications and decoration. Sometimes this may, however, extend over onto the left hand side of the centre line (Fig. 44) but the left hand side is otherwise left blank when drawing this type of pottery.

Handles (Fig. 45)

When only one handle is present it is drawn on the right hand side of the vessel (Fig. 45a). If the vessel has two, one on either side, one is drawn on the right to show the exterior profile and one on the left is drawn in section to show how they were fitted onto or into the body (Fig. 45b). Pots with more than two handles are drawn with one on the right and the others in whatever position they have on the pot orientated in this way (Fig. 45c). Sometimes it may be necessary to omit some of the vertical dividing line in order to show a centrally placed handle. In order to show all the decoration on a handle more than one view may be necessary (Figs. 45e and f). If the handle is decorated on the outside, a separate illustration of this may be necessary. To do this, position the pot above the elevation drawing with the handle on the right. Keep the rim on the same horizontal line as the elevation drawing and rotate the vessel to the left until the handle faces upwards. Now draw this view of the handle, to the right of the elevation and section (Fig. 45f).

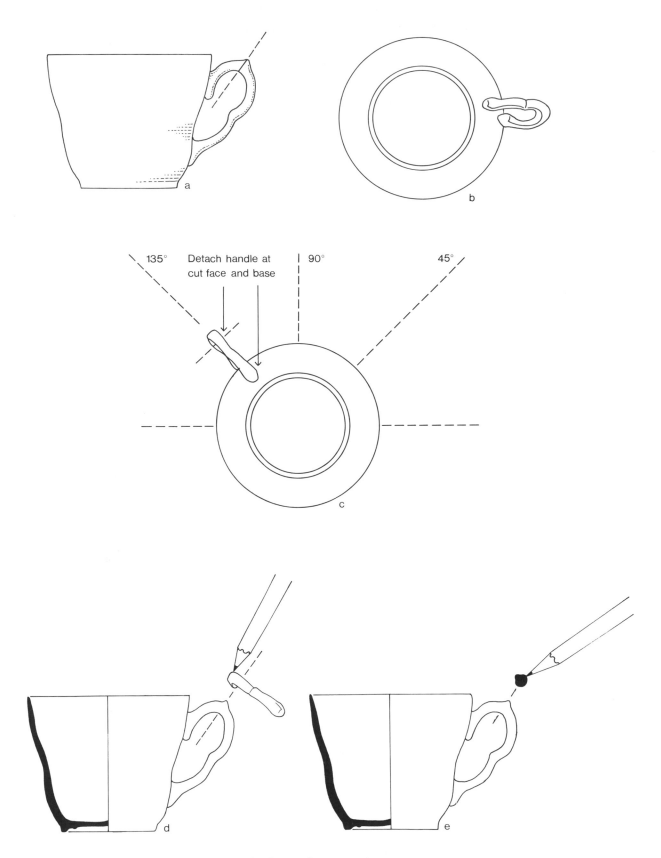

Fig. 46 How to draw a section

Spouts (Figs. 47a to e and 48b)

Spouts are normally placed on the left of the elevation view and shown in section. The type, i.e. bridge (Fig. 48b), tubular (Fig. 47d), etc. and method of attachment should be made clear. If the section does not show it in enough detail, other views can be drawn.

Lips (Figs. 47f and 48a and c)

If a spout only protrudes slightly from the profile of the vessel, it is called a lip. Either take the section through the centre of the lip (Fig. 48c) or draw the plain rim profile and just outline the lip to the left.

Fig. 47 Spouts and lips. (1:1, r1:4). a) Spout shown on the front of a vessel with a separate view showing it in section (note extra clay wrapped around it). b) Small spout shown in section and plan (note thumbing in plan view). c) Spout sherd - several views including section. d) 'Tubular spout'. e) 'Tubular spout' in shape of horses head. f) Lip shown in section and plan.

Body sections

To emphasise the mode of construction, handmade sections are hatched from bottom left to top right (Fig. 49a). If the pot is drawn at the usual scale of 1:1 for reduction to 1:4, a size 0.4mm pen is used and each line is 2.5mm from the next on the initial drawing.

A T-square ruler and 45° set square can be used to make hatched lines by hand, or a machine can be used (see General Principles section p.9). Wheel thrown sections are blacked in (Fig. 49c). It is usual to black in sections on prehistoric pottery, even though it is handmade. This is contrary to the approach described above for all other pottery.

By the way these wheel-thrown lines are drawn, the viewer can determine whether a pot was more regular and perhaps thrown on a more sophisticated wheel, or less regular and thrown on a less sophisticated wheel, or with less skill. The period can also be ascertained. Roman and other very regular mass-produced, wheel-thrown pottery should have their horizontal wheelthrown marks drawn with a ruler (Fig. 50), but Saxon and medieval pottery wheelthrown marks are drawn by hand (Figs. 45 and 49) to emphasize their unevenness. Handmade pottery is always inked in 'freehand' as this is the best way to depict irregular, more uneven lines.

"Ring" or "coil" built pots often have similar horizontal marks where each coil meets the one above. These should be drawn by hand.

Look out for finger or nail marks and other indentations (either accidental or decorative), extra pieces of clay used either to secure a handle/body join, spout/rim join or to strengthen other parts of the pot, e.g. the base of a Siegburg jug (Fig. 51) or for decoration, e.g. ears (Fig. 45a). Look out for signs of turning or knife trimming to pare down the vessel walls (Fig. 52).

All these features will give valuable information on how exactly the pot was made.

Fig. 48 Spouts and lips (1:1, r1:4). a) An early London type ware jug showing section taken through the body of the pot and the lip outlined to the left. b) A London type ware jug with 'bridge spout' and applied roller stamp strips, and scales. c) London type ware tripod pitcher showing the lip in section on the left.

Characterisation and shading

Fabric

In order to characterise each individual piece, the various types of pot are illustrated according to their 1) fabric; 2) constructional marks; 3) finish; and 4) decoration. Most fabrics will have certain distinguishing features on their internal and external surfaces which characterise the type of clay used to make them. Coarse and fine fabrics can be indicated with clusters of stipple and more evenly spaced stipple respectively (Fig. 49). Inclusions such as shell (Fig. 49a and b), quartz (Fig. 50) and chaff should be outlined when present. This will apply mostly to unglazed ceramics.

Constructional details

Wheel-thrown marks. Although it will be obvious by the way the section is shaded whether a pot was handmade or wheel-thrown, these should be drawn where present on both internal and external surfaces.

Fig. 49 Characterisation and shading (1:1, r1:4). a) A shelly cooking pot, crosshatched section to show it was handmade. b) Spouted pitcher showing shell and quartz inclusions in the fabric. c) Finer fabric with wheelthrown section blacked in.

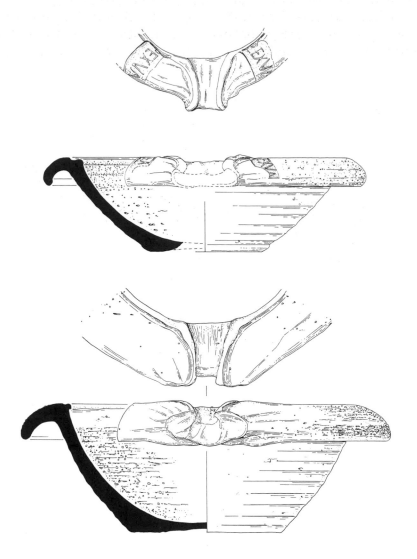

*Fig. 50 Roman mortaria with stamps showing quartz inclusions
and wheelthrown lines done with a ruler (1:1, r1:4).*

Finishes

Some vessels, e.g. many Saxon cooking pots, are left with little or no decoration and no glaze, and only the fabric to characterise them (Fig. 49). Others may be covered with slip and/or glaze. Slipped areas may be indicated using a single, and occasionally double, broken line (Fig. 48b). Glazed areas may be indicated with three lines of dots, the distance between the dots decreasing the further towards the centre they are (Fig. 45b and 48c). However, if they are coloured, the edges of these areas will not be delimited in this way (see colour conventions). Burnish may be used to give a shine to the surface, and this is also indicated by broken line (Fig. 43). Here the pot has been dried to the leather hard stage and then buffed up with a smooth stone, piece of wood or cloth, for example. Sometimes this is decorated further, e.g. with latticed lines (Fig. 53). This is also depicted using broken line.

Types of decoration

Simple decorative techniques include nail and finger impression (Fig. 47b and 49c), stamps (Figs. 51 - 52), combed and incised decoration (Figs. 42 and 45d). Clay bosses, strips, pellets, etc. may be added to the surface (Fig. 48b) of the vessel. Other decorative techniques include the use of coloured slips, oxides and glazes. These are all shaded according to certain colour conventions.

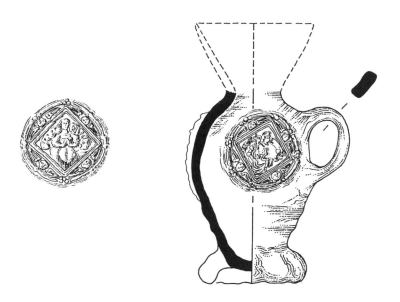

Fig. 51 *A Siegburg jug with extra clay wrapped round the base and a medallion on two sides. (1:1, r1:2)*

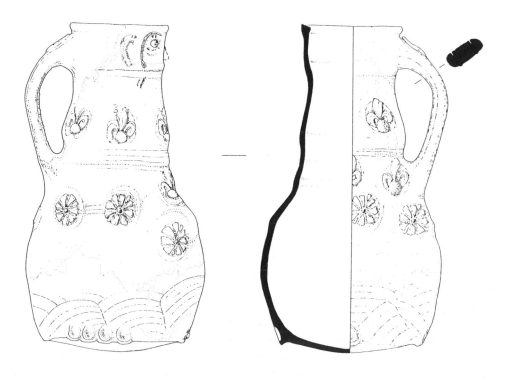

Fig. 52 *A stamped vessel with knife trimming around the base (1:1, r1:4)*

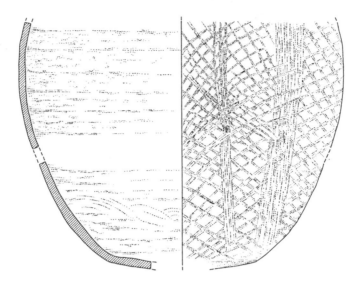

Fig. 53 A burnished pot from Domburg with lattice decoration (1:1, r1:4).

Colour conventions (Fig. 54)

Unlike small finds there are no universally accepted rules for depicting colour on ceramic vessels, as the conventions used will depend on the type of design and number of colours on each vessel or group of ceramics. A linear system, for example, is not ideally suited to complicated designs, particularly when illustrating curvilinear decoration. Stippling is often more suitable for this, but it is not always possible to create enough textures using stipple alone, particularly when a number of colours exist side by side.

Most conventions consist of different spatial arrangements of dots and lines. Equidistant horizontal, vertical and diagonal lines as well as different densities of dots can be drawn, using a variety of pen sizes, to indicate each different colour. By placing them closer or further apart, darker and lighter shades can be indicated.

As conventions vary from one institution to another as well as from one group of pots to another, it is important to include a key with each page of illustrations. If they remain constant throughout the article/report/book, it is sufficient to provide only one key at the beginning (see Hurst and Neal 1986).

When shading coloured areas it is important to depict the original colour and not the colour they have taken on over time. This may not represent the true colour, but more a combination of the original colour and a series of further chemical reactions between that, the fabric of the pot, its contents and the soil/environment in which it was found. Tin-glazed ware, for example, which has a white background which is then painted with certain oxides e.g. cobalt, often turns black when buried in cess, but should not be shaded black.

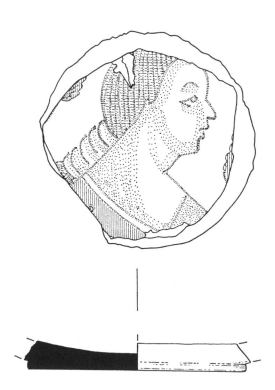

Fig. 54 (Above) A colour convention chart for pottery

(Below) A Montelupo tin glazed bowl iragment in blue, yellow and green (1:1, r1:2)

Methods of depicting decoration (including plans)

If a continuous pattern exists it may be necessary to flatten or 'roll' it out (Fig. 55a). If a pattern is painted onto the vessel and does not protrude sufficiently from the surface to enable a rubbing to be made, it may be possible to trace the decoration. This can be done by wrapping transparent paper or tape round it and copying the outline onto it. This can then be traced onto cartridge paper. When checking the tracing, measurements should be taken at approximately 5 mm. intervals around the pot as the curvature will distort measurements taken at much larger intervals.

When a pattern repeats itself around an object it is not necessary to draw a number of different views and one will be sufficient, even when the design is slightly irregular (Fig. 55b). The usual elevation view, or the one that shows the external surface on the right, and the section on the left as you face the page is all that is necessary. Each design element is measured with dividers held so that the two points are always equidistant from, and parallel to the plane of the drawing surface, as if the vessel were in fact a rectangle with decoration on its uppermost flat surface. Many illustrators project down from their dividers by eye, placing the dividers first immediately above any two points they wish to measure on the design, and then transferring this onto the paper in the correct place within the outline. However, most pots are cylindrical. If the vessel had equidistant vertical lines around its circumference they would appear closer at the edge.

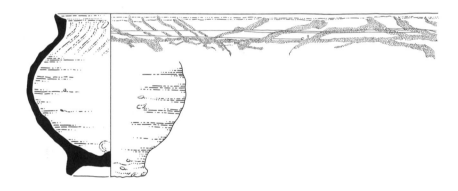

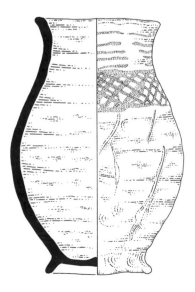

Fig. 55 Red painted wares: (1:1, r1:2)
a (above) A pattern "rolled out" to show all its elements in a "frieze"
b (left) A simple repeated pattern which repeats itself around the vessel. Only one view is necessary here.

Some people find it useful to stand the pot next to its outline on the page, place an engineer's square next to it and use the dividers to project across to any given point on the decorated area of the pot at right angles from any given point on the engineer's square. This gives vertical and horizontal measurements which can then be transferred on to the paper.

If the decoration is complicated or difficult to draw by eye, a more reliable but time consuming approach can be used (Fig. 56a and b).

First place a T-square along the base line, then rest a right angled set square against it and slide it along the T-square until its vertical edge touches the point of the pot's widest girth.

Draw a vertical line, finishing it well above the top of the illustration, at least the equivalent of the pot's diameter. Do the same on the other side and extend the central vertical line up to the same height.

Now stand the actual pot in between these lines and above the elevation drawing. Use the engineer's square to make sure it is in the correct position, its widest parts immediately above these lines. Place an engineer's square on the central line so that it touches the edge of the pot.

Draw a horizontal line at the top, bottom or any other known or notional horizontal line on the elevation view. This may be an arbitrary line so many cms. up from the base of the pot (measured on the engineer's square) or, for example, the top or bottom of a panel around the pot.

Draw another horizontal line at right angles to the central vertical line and a few cms. above the top of the elevation drawing. Measure the radius of the horizontal drawn on the elevation view using a compass. Place the point of the compass at the junction of the uppermost horizontal and central line and draw an arc to join the two together.

Using the dividers, this time so that both points touch the pot along the chosen horizontal line, measure each point where the pattern touches that line. Start with one point on the centre line and measure out. For each measurement the dividers are taken from the pot and, starting at the junction of the centre line and the arc, put a dot where the points of the dividers touch the arc. When you reach the point where the arc touches the horizontal line, stop.

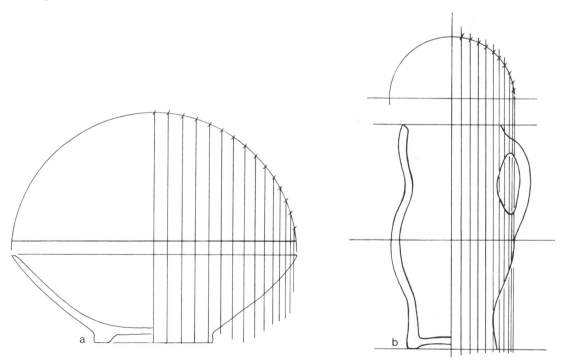

Fig. 56a and b How to measure and draw decoration on the elevation view of (a) a dish and (b) a jug.

Using the T-square and set square, project down from each point on the arc to the line chosen on the pot and draw a dot. Any number of horizontals can be chosen and the process repeated, but it is preferable to rub out the uppermost horizontal, arc and points around it or confusion may set in.

This method is also useful when the correct amount of foreshortening is uncertain when transferring a three dimensional object into a two dimensional illustration. A repeated regular pattern will inevitably appear closer together at the edges than the centre of a cylindrical object.

If necessary a design can be taken across the centre line into the other half of the pot (Fig. 57a and 58) and even extended across the entire view (Fig. 57b). If this is the case a further view or a number of views can be drawn, one of which should include a section.

Fig. 57 a) A sherd reconstruction with the central line shifted to the left to allow room for all the external decoration.

b) Three views of a "face jug" to show section front and side views (1:1, r1:2).

Stamps, bosses and details

All ceramics are normally drawn at 1:1 for reduction to 1:4, but when a design element such as a stamp or boss is small, it is often drawn on the pot at 1:1 and then scaled up to 2:1 and drawn again. This enables the illustrator to depict more detail, and give its true dimensions which may be foreshortened on the curved wall of the pot. When mounted with the drawing of the pot, it will reduce to 1:2 (Fig. 58).

Fig. 58 Late medieval Hertfordshire glazed ware jug with "stamped boss" decoration. (Jug 1:1, r1:4 stamp 2:1, r1:1).

Plans (Figs 59, 60 and 61)

A plan is a bird's eye view, looking down onto an object. It is always drawn in conjunction with an elevation to provide further information on the object in question, but when no further light can be shed on an object by drawing a plan, the elevation view will be sufficient. This applies to simple repetitive motifs which fit into the elevation.

When to draw a plan

When drawing bowls, dishes and plates (all open forms) which are decorated on their uppermost surface with designs which were intended to be viewed as one complete picture and not squeezed into one half of an elevation view. A figure painted onto the middle of a bowl would, for example, have to be cut into a quarter to fit into the left hand side of the elevation (Fig. 59).

When the decorated area is on a sloping or irregular surface which distorts or hides the true picture.

When the base of a pot is decorated or modified.

If a plan is drawn it is not necessary to shade the area it represents on the elevation drawing, as this would be time consuming and would not add any further information about the vessel.

Fig. 59 Lustred bowl with plan of top and base (1:1, r1:2).

To draw a plan

The outline: If the rim is very regular an outline can be drawn using a compass. When it isn't, turn the pot upside down and place it on a sheet of tracing paper and draw round it. Turn the tracing paper over and place it on top of a sheet of cartridge paper or immediately above the elevation view and draw over the lines.

The pattern: When copying the detail on the pot onto the drawing, measurements must be taken by placing the points of the dividers immediately above the points to be measured and parallel to the horizontal plane of the drawing board. Imagine a flat, transparent surface stretching from rim to rim. Both points of the dividers must touch this when measuring the dimensions of the decorated area below. This isn't easy by eye, so some illustrators place a frame, with transparent plastic stretched across it, over the vessel to be drawn. A Rotring or fine felt tip pen can be used to copy the decoration onto the plastic. This is then removed and placed on top of a light box with a piece of cartridge paper on top of that. The outline of the decorated area will then be projected onto the cartridge paper and can be copied onto it in pencil. Allow plenty of time for the ink to dry on the plastic before putting the paper on top of it!

A more complicated but accurate method can be used to measure the correct position of chosen design elements within the plan outline (Fig. 60). This relies less on aligning the dividers immediately above each chosen point, by eye, and more on measurement.

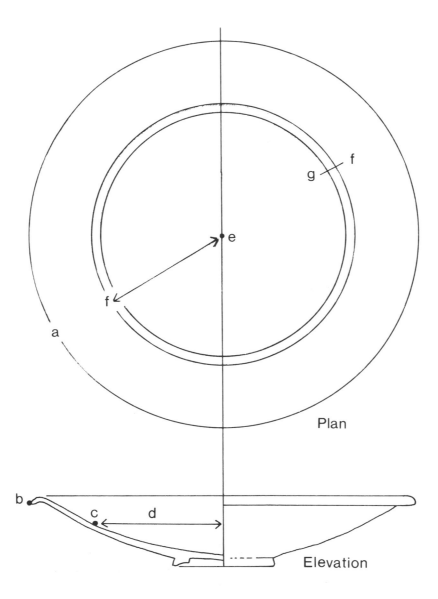

Fig. 60 Diagram of how to measure and draw decoration (particularly bands on a plan).

Measure the radius of the rim with a compass, extend the central vertical line up from the elevation and, placing the point of the compass on that line, draw a circle immediately above the elevation view a). If the vessel is incomplete draw a curve the size of the remaining sherd. Using the dividers, measure the distance from the edge of the rim to any chosen point on the decorated area of the pot. This time the points of the dividers should touch the inside edge of the vessel. Transfer the dividers onto the elevation drawing, place one point on the rim (b) and place a dot where the other point touches the inside of the section (c). Now draw

a horizontal line from this point to the central line (d), using a T-square or set square to ensure a 90° angle. Set a compass to the same length as this line, and placing the point on the centre point (e) of the plan outline (a), draw a circle. This marks the distance any chosen point on the plan will be from the rim. It is particularly good for locating 'bands' of decoration which often extend around the circumference of the pot (f-g), see also Fig 61.

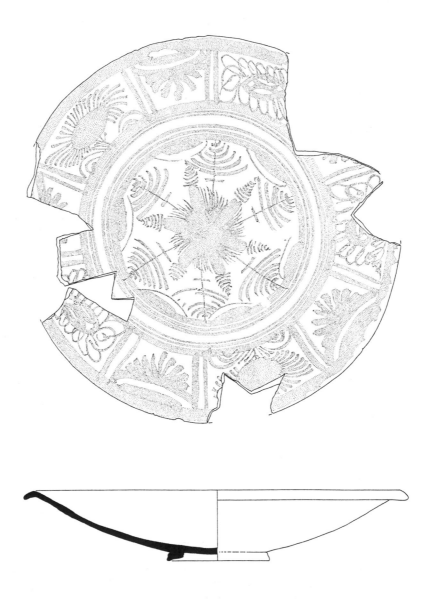

Fig. 61 A plan view of a tin glazed ware dish. (1:1, r1:4)

Samian ware

The finely made red-coated Roman pottery known as Samian, very common on Roman sites, is drawn using different conventions.

Normally, only decorated sherds and potters' stamps are drawn, and the method of drawing differs from the usual pot drawing technique in that no cross-sections or outside views are drawn, but only the decoration.

Decorated vessels

The emphasis in illustrating Samian is on the precise shapes and locations of the decorative elements. Since to depict this on paper one has to 'flatten out' the curved surface of the pot, it is extremely difficult to draw the decoration by measurement alone.

The standard (probably the only accurate) way to draw Samian is to make rubbings on tissue paper and to use them as the basis for the drawing. Thus the drawing exactly reproduces the arrangement of the decoration, and the true spacing of the designs, as well as showing any distorted or broken elements.

Samian is usually drawn at 1:1 (actual size) for reduction to 1:2. Certain materials are necessary for drawing Samian, particularly tissue paper and graphite. The ideal tissue paper is cigarette paper, which can be bought in small packets ("Rizla"), though these are really too small for all but the very small sherds and stamps (of which more later). Large sheets may be obtainable through tobacconists - or by writing to a cigarette producer! If cigarette paper cannot be obtained, ordinary tissue paper can be used, the smoothest and softest is best.

Powdered graphite can be obtained, in tins, as it has various commercial uses. A word of warning : it is usually in a fine powder form, and given the chance will get everywhere! When not in use the lid should be taped down, the tin being kept in a polythene bag (sealed) or a box.

If graphite is unobtainable, very soft lead pencils, (6B or softer) can be used instead. Although this is a cleaner way of drawing Samian, it is more difficult to get a rubbing of all the fine detail with pencils.

The actual procedure is as follows: hold (or with a large sherd, tape) the tissue onto the area to be rubbed, so that it covers the whole sherd and can be folded over the edges. (Tape onto the back of the sherd with drafting tape if this will help to keep the tissue firmly in place. It must not be allowed to move. Now dip a thumb or finger in the graphite (or take the soft pencil), and rub it over the tissue to produce the rubbing. Use some pressure to ensure that fine or shallow details are reproduced, and to rub into angles etc. Experience will soon show how dark the rubbing needs to be.

Remove the tissue paper and then transfer the image to white paper or board: either using a light-box with the paper overlaid, or by the traditional tracing paper method - turn the rubbing face down and rub across the back with a soft pencil; then place it on the paper and draw round all the details to produce a pencil drawing (probably slightly smudgy) on the paper.

Ink this in using 0.3 (or 0.35) and 0.2 (or 0.25) pens. The technique is purely linear, the lighting falling from the top left, so one is depicting the light and dark edges of the raised decoration. If anything is cut into the surface, reverse the placing of the light and dark lines. Use a 0.4 or 0.5 pen for the rim line and for both the lines of the footing, if present. Unless it is very distorted, this can be compass drawn.

Whilst inking in the drawing refer frequently to the sherd, as there will often be odd corners where the rubbing is unclear. Fill in any small missing bits carefully by eye and by measurement.

A glance at published Samian drawings will show that the arrangement of the drawings varies: if it is a single sherd, it is drawn as a simple 'flat' drawing. Where several

sherds join, or where there is a complete profile of the vessel, it must be 'flattened out' in the drawing - and with, for example, a deep bowl this is not always easy.

The answer to this is that, fortunately, the decoration on Samian tends to run in bands or zones, and the drawing can be divided up accordingly. The top of the rim, if it is vertical on the vessel, is drawn as a HORIZONTAL line; the base, or footing, if present is drawn in plan, and the areas between are laid out according to the diameters given by the rubbing.

Fig.62(a) shows the way a pot would normally be drawn; (b) shows how it should be depicted as Samian.

Only enough of each zone or band to show all the different elements need be drawn - for example if the decoration consists of four groups of gladiators repeated in panels, draw a run of four panels, plus enough of the adjoining panel at each end to show that the pattern repeats. If the panels repeat, but in a random order, then the entire circuit will need to be drawn.

Similarly, scrolls or vine tendrils need only show a complete scroll and the beginning of the next scroll in each direction, unless the scrolls are varied, in which case a complete run will be needed.

Rouletted or ovolo patterns beneath the rim, and bead rows bordering the panels tend to be the exceptions (Fig. 63). In the case of the former, they are usually drawn a bit longer than strictly necessary in order to make a balanced drawing (Fig. 64).

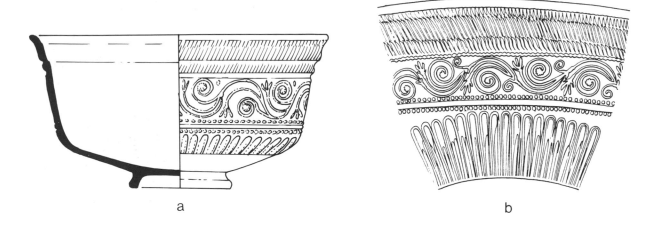

a b

Fig. 62 Samian vessels, decorated.

Rouletting Ovolo Bead row

Fig. 63 Samian details

Fig. 64 Samian decoration, "unrolled"

Fig. 65 Samian decoration

Bead rows tend to border or divide areas of decoration, and should therefore run as far as the element they are bordering. Which raises the question, "does the bead row go with the element above (Fig. 65a) or the element below (Fig. 65b)?"

Both convey the information. It is perhaps best left to the illustrator's discretion, accepting that no single rule can be applied. Some bead rows will clearly be a separate element (Fig. 66a), whereas others will be part of a decorative scheme (Fig. 66b).

Another form of decoration found on Samian, though far less commonly, is the so-called "Cut glass" style. As the name suggests this closely resembles cut glass, and consists of sharply defined incisions into the surface of the vessel. It is best treated with fine line shading to represent the sharply incised nature of the decoration, where the cuts are wide enough. If too fine, merely light and heavy lines can be used (Fig. 67).

Fig. 66 *Samian sherds*

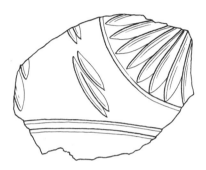
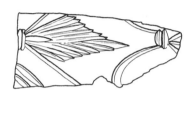

Fig. 67 *Samian cut-glass decoration*

Dotted lines to indicate missing portions should be omitted unless specifically asked for; broken edges are usually drawn in as a single line, as this makes it clear that decoration is missing and is not merely omitted for convenience (e.g. at the end of a sequence of repeating panels).

Stamps

These are potters' name stamps, indicating the potter who made the vessel, or in some cases the artists who made the moulds in which decorated Samian vessels were produced. Rubbings of stamps are made for, and usually by, the specialist writing the report. For publication, stamps are drawn at 2:1, for reduction to 1:1.

The stamps are simply measured and drawn out as accurately as possible. Some work has been done on dating phases of a potter's work by the degree of wear on his stamps, so accuracy can be crucial.

Sometimes stamps on bases are surrounded by, overlain by, or overlie, spiral or concentric grooves. These grooves are important only where the stamp is distorted or damaged by the groove. Only then do they need drawing, using a light and dark outline (Fig. 68 overleaf).

If a decorated vessel has a stamp included within the decoration, it should be drawn, by rubbing, as part of the decoration; and then measured and drawn out separately as a stamp at 2:1, and placed alongside.

Line weights for the stamps are 0.3 and 0.2 (or approximates), once again shaded from the "top left".

Fig. 68 Samian stamp

Fig. 69 Samian stamps

If the stamp is deeply impressed it may be worth using a 0.4 pen for the shadow edges of the depression (Fig. 69).

Plain vessels

Plain Samian ware is occasionally drawn for publication - for example, as part of an important dated group. It is drawn out using the normal pottery conventions of half section on the left, half elevation on the right, using 0.4 outlines and 0.3 for any other lines (for reduction to 1:2). Stamps are drawn out as described above.

If a plain Samian bowl has a vine scroll or similar on the rim, this need not be drawn as a plan unless it is an elaborate example: the normal pottery view will be sufficient.

If a large amount of plain Samian is to be drawn, it is now generally acceptable to draw only the left-hand, section side (Fig. 70). Similarly, if a section of a decorated vessel should be needed, only the section half need be drawn (Fig. 71).

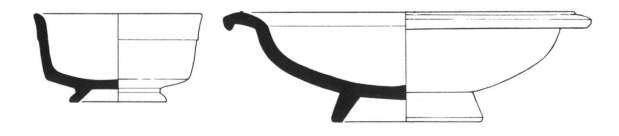

Fig. 70 Plain Samian vessels

It may be decided to publish any plain Samian at a smaller scale than the 1:2 usual for decorated pieces. 1:3 or 1:4 are the most likely alternatives. If this is the case, the line weights used should be increased, for example to 0.5 and 0.3 (or 0.35) for reduction to 1:3, and 0.6 and 0.4 for reduction to 1:4.

Fig. 71 Half-section of a Samian bowl

Glass vessels

To illustrate glass well it is necessary to know a little about how it is made, in order to show the marks left by different processes. Before putting pencil to paper it is important to pick the piece up and try to determine its various components. Some Venetian wine glasses, for example, often have a "merise" or flat disc separating the bowl from the stem, and another between the stem and the foot, whereas certain English pieces have only three components: foot, stem and bowl. These distinctions must be made in the illustration.

When a vessel has been made on a blow pipe rather than in a mould, a "puntil" mark will be visible. These marks are found where the piece is broken off the pipe which was used to form it. However, some pieces are both blown and formed in an optic mould or 'mezzaforma' to give a final result which is half moulded or ribbed and half smooth. (This process has been in existence since the Roman period and can be seen in evidence on bowls sold in the shops today.) Accurate depiction of the shape of the mouldings on the bowl will help determine the shape of the 'optic' mould used and must therefore be carefully recorded (Fig. 72).

Fig. 72 Two glasses with moulded decoration (1:1, r1:2)

In the past glass vessels were often skilfully depicted and attractive to look at (Fig. 73), but gave no indication of the true dimensions of shape or decoration. Nowadays glass is normally illustrated in the same way as ceramics, the object being divided into two down the centre with the left hand side showing the exact dimensions of the section and interior of the vessel and the right the external surface (Fig. 72). Reflections on the surface of the vessel are not included as this information is not integral to the understanding of the form itself and will, of course, vary according to its position. Although this may not look so attractive it is more accurate, easier to achieve, and less ambiguous to the reader. It may be necessary to make a separate illustration to depict a complicated pattern when it stretches across the width of the entire vessel, but otherwise one will be sufficient.

Glass illustrations (Figs. 2 and 72) differ from pottery (Figs. 40-55 and 57-9) in their simplicity and need only consist of an outline with a small amount of shading to accentuate the shape and suggest the form. Line rather than stipple is the best way of depicting the smoothness of glass, except when a specialist particularly requests an illustration of the slight colour changes caused when the glass was 'blown'. In this case it may be necessary to do another outline of the vessel and shade these marks in stipple (Fig. 2). If a piece is very highly moulded or decorated it would be impossible to depict pattern and colour changes on the same drawing without overcrowding and subsequent loss of clarity.

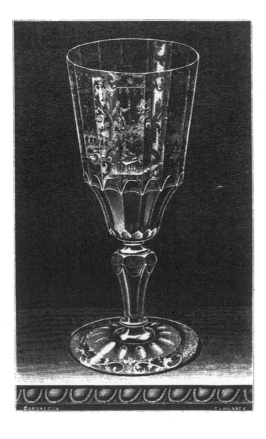
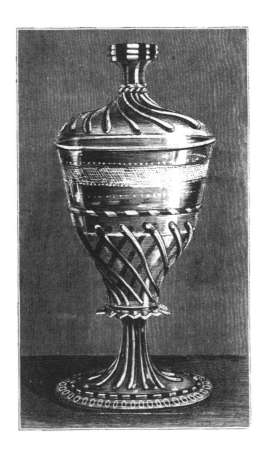

Fig. 73 Two glasses from Alexandre Sauzay's "The Wonders of Glassmaking in all Ages".

Many publications only use photographs to show the intricate decoration on some glass pieces, but drawings are vital in order to give information on the true dimensions and proportions without the distortion caused by light reflecting off the surface. Drawings are also particularly useful for conservators to send to glass blowers so that they can reconstruct the missing parts of valuable objects without the worry of transporting such delicate items.

When inking in, use a 0.3mm. pen for the outline and a 0.2 for the shading. This will then reduce to half size or can be left at 1:1 for publication. Some illustrations have the section inked in solidly in black while others are left as outlines. This is simply determined by the thickness of the glass wall. If it is very thin the outlines may merge and look messy. In these cases it is better to ink them in intentionally as this always looks neater.

Certain glass illustrations have been published in pencil and this can give very pleasing results as long as the shading is heavy enough to be picked up in the printing process. Since pencil drawings will not reproduce on the line film used for ink drawings (unless drawn in a very heavy black pencil), they need to be treated as photographs and printed on glossy paper, which is more expensive and not always acceptable for publication. Examples of published pencil drawings can be found in Ingeborg Krueger's "Die Glasfragmente aus einer Grube bei St. Quirin in Neuss".

Drawing flint and stone tools

Christine Wilson

Archaeologists concerned with flint or stone artefacts not only need to know the shape of the piece but also the sequence of steps by which it was made. This means that the illustrator does not simply put down that which he 'sees' - when the light is coming from the top left - but that which he 'knows' is there.

This may sound mysterious but in practice the illustrator is simply picking up on the properties inherent in the material. When a piece of flint is struck with sufficient force to detach a flake, shock waves move out from the point of the blow in concentric circles. Usually these can be seen as surface ripples. The arcs produced by the blow are used by the illustrator to describe the shape of the artefact (i.e. as a convention for shading) and to inform the archaeologist about the manufacture of a piece, showing the point from where each facet was made and in what sequence.

The following is intended as a beginner's guide and a check list for those who may only be asked to draw flint tools infrequently. The most comprehensive and useful publication for anyone wanting to draw flint and stone tools is *Précis de Dessin des Industries Lithiques Préhistoriques* by Michel Dauvois. The diagrams and illustrations are extremely clear, and even if you don't read French it is possible to follow the techniques involved and be inspired by the drawings.

Background information

The material

It is possible to work out how a flint artefact was made because flint is a fine-grained, homogeneous material and retains on its surface an impression of the radiating shock waves mentioned above. Similar impressions occur in other materials from which stone tools were made, but their visibility depends on the grain size of the medium (e.g. obsidian, a naturally occurring glass, shows very clear and lively arcs while quartz, a larger grained material, may have no discernible ripples). The drawing technique is modified accordingly.

The artefacts (terminology)

The majority of tools are made on flakes struck from a larger piece or core. Flakes always have a characteristic form. The major wave, at the point of impact creates a bulge (bulb of percussion), on the side facing the core (Fig. 74). Flakes which are deliberately manufactured to be longer than they are wide are described as blades and archaeologists differentiate flake tools and blade tools because the production of blades indicates a watershed in stone tool technology. An illustrator may also be asked to draw the cores themselves or parts of the cores discarded during the production of flakes and blades, e.g. core tablets, the top surface of the core, or crested pieces, waste material from a core being shaped to produce blades. Bifaces are tools worked more or less equally on both sides (bi-facially) such as a hand-axe, and very often the bulb of percussion is absent or has been erased during the manufacture of the piece.

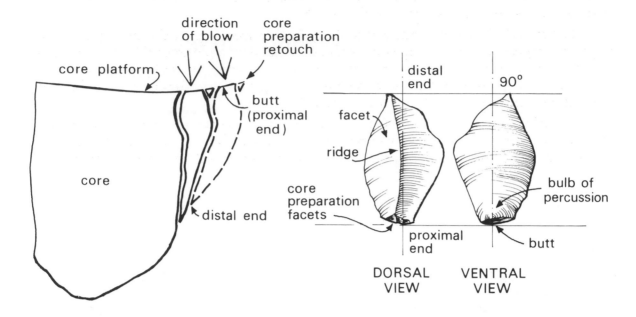

Fig. 74. The production and main features of a flake or blade in relation to the illustration of an artefact.

Terminology and its implications for drawing

The side of a flake (or blade) nearest to the core where the bulb of percussion develops is known as the ventral (i.e. stomach) surface, however, for illustration purposes it is regarded as the less important face of the flake. The surface facing outwards from the core, that which shows the concavity created by the bulb of percussion from previous removals, is known as the dorsal (or back) face (again see Fig. 74). For both typological and drawing purposes this is normally the most important aspect of the tool, and if only one view is required, the dorsal surface is that usually drawn.

The part of the flake which was at the top when the blow was struck is known as the butt or proximal (nearest) end. This is always (unless you are otherwise directed) put at the bottom of the drawing. The end furthest away from the knapper is called the distal end and put at the top of the drawing.

An illustrator is seldom asked to draw a flake or blade which has not undergone further working unless it shows evidence of edge damage (see below), or is technologically significant.

Retouch (i.e. pieces struck deliberately or accidentally from the flake) creates the same characteristics as flakes struck from the core. However small, the impression left on the flake shows the concave, negative form of the bulb of percussion and residual concentric shock waves. This is the most important thing to remember when shading (Fig. 75).

The impression made on the core by the removal of a flake, or the impression left on the flake by retouch is known as a facet, or less commonly, a flake scar. It has a characteristically concave form. Ridges occur where neighbouring facets meet; they are the intersections where the radiating arcs come into conflict and are crucial for drawing as they form the outline of the facets.

An unworked nodule of flint has a white residue (or cortex) on the surface. The first flakes to be struck therefore have cortex on the dorsal face, and are called cortical flakes. Where cortex occurs on a piece, whether on an edge or surface or as an inclusion within the

flint, it is shaded (i.e. its form is described) by using dots (Fig. 77). This usually holds true, even when it is not necessary to shade the facets.

Flakes and blades are made into tools by further working. This is perhaps the most important aspect of a tool as it not only shapes the flake for a particular use, but may have typical characteristics which assign it to a culture or period, or indicate the method of manufacture (e.g. pressure flaking, prising or levering a piece of flint away by means of a pointed implement such as the tip of an antler (Fig 75e)).

Often beginners assume that the larger facets are the most important; in fact all facets (for drawing purposes) are equally important, but there is a tendency, certainly noticeable on the poorer published drawings, for the edge treatment to be stylised (small retouch may

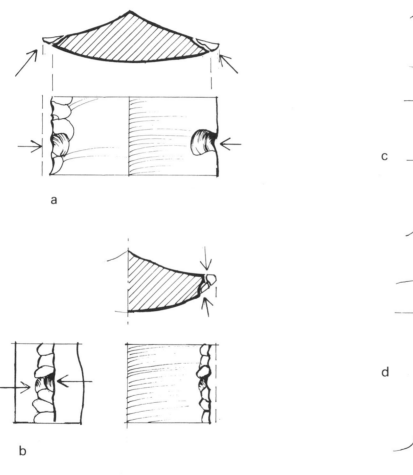

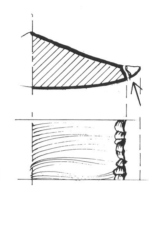

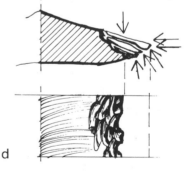

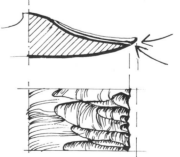

Fig. 75. Retouch. Retouch, intentional or accidental, is caused by blows to the edge of a flake.

a) The retouch facets show the negative bulb of percussion

b) Retouch may be made on either face. It is important to observe from which direction the blow came, and indicate it when shading.

Retouch may be:

c) Steep or abrupt. Characteristically even and regular.

d) Complex/scalar. Made by chipping into the edge, causing undercutting and shallow invasions of the surface.

e) Invasive (eg pressure flaked). Shallow, smooth, with flowing ripples.

(Requires subtlety when shading or the piece will look flat.)

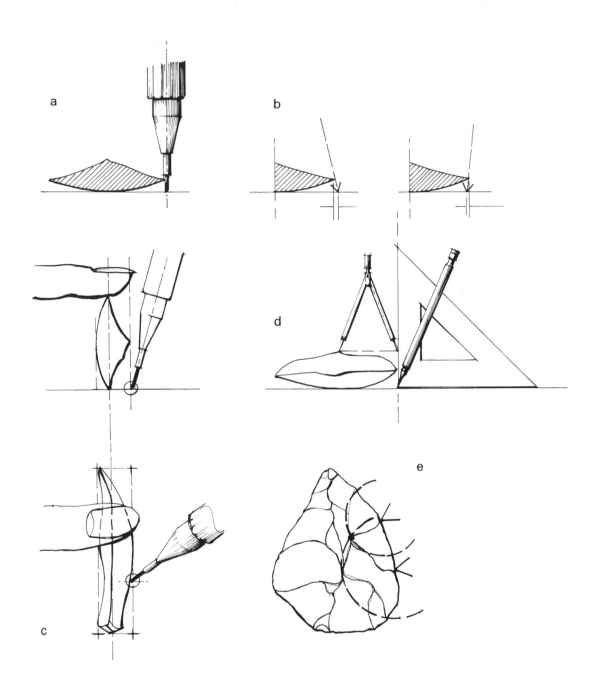

Fig. 76. Obtaining accurate outlines and measurements.

a) Position of pencil (and eye) should be vertical to the edge of the piece.

b) A slight movement in either direction causes distortion of the view.

c) Drawing the profile. The eye must be kept vertically over the edge so that the pencil point can follow the outline.

d) For thick pieces, points on the edge can be marked out with the aid of a set square. Points away from the edge can be located by using dividers as shown.

e) A point can be located by using a set square and a pair of compasses. The point is transferred to the drawing by producing intersecting circles from two positions on the edge.

be shown as a series of indistinguishable loops). This is an abrogation of the function of the illustrator, a) because the illustrator should be producing a true record to the best of his or her ability, and b) because the reader needs to see what the tool is really like, and what appear to be minor details can have meaning for the archaeologist. Abrupt, stepped and invasive are terms used to describe retouch (Fig. 75). An archaeologist may distinguish deliberate retouch, use wear (facets, nicks and abrasions caused by using the tool) and post-depositional edge damage, which can be the result of geological or climatic conditions, or take place during excavation or poor conservation.

The process and conventions of drawing

It is tempting to select the most 'interesting' (or complex) piece to start with. If you have not drawn flints before, or for some time, it is better to begin with the simplest artefact in the batch, to get your eye in and build confidence.

Starting to draw

You will need cartridge paper, a clutch pencil, soft eraser and perhaps a small piece of plasticine (assuming that a flat, uncomplicated, retouched flake or blade is being drawn). Making sure the bulb of percussion is at the bottom, place the artefact on the paper, dorsal surface up and, holding it down firmly with your left hand, trace around the edge. The pencil should just touch the edge of the flint and be as close to 90° as you can comfortably manage. When an artefact is to be analysed for microwear, the edge should not be touched under any circumstances. This will be discussed under "Special cases" below. The pencil has a slim metal lead-holder, enabling you to get very close to a true representatiaon of the outline where the lead touches the paper, and by extending the lead (to a maximum of 6 mm.) it is possible to get even closer. Don't press down too hard, or it will break!

It is useful, from the start, to develop the habit of keeping your right eye (if right handed) directly over the point of the pencil, and moving along with it. It is very easy to misjudge the position of the outline, even on relatively flat pieces, due to the distortion caused by perspective or the angle of view (see Fig. 76). If you have difficulty tracing round the butt and left hand edges, just rotate the paper, holding the flint in place, until it is comfortable to keep your eye over the point again.

When you have finished, move the flint over alongside the outline and compare them. However much care has been taken, there are likely to be anomalies which are a result of the process and which can't be avoided. For example, retouch which on the piece is a series of crescent shapes with sharp points in between may have become a line of V-shaped nicks with rounded points. This occurs because the lead is being dragged from top to bottom and sticks on the paper. Although it may seem pernickity, it is advisable to correct any differences you see, a) because the edge identifies the 'character' of the piece and, as mentioned, the retouch is important, and b) because the edge is the most direct and useful guide you have for drawing in the facets. On small pieces distortions will be relatively magnified. Sharp indentations will become rounded because the lead is too large to get into a corner, or the distal end will look less delicate and pointed than it is on the artefact. When 'correcting' it is possible to press down with the pencil a little harder. This gives life and immediacy to the drawing and is shown in Fig. 77, together with the main stages in producing a drawing.

The ventral outline

You will need tracing paper and a set square. Rule a faint vertical line through the outline of the dorsal view, bisecting the bulb of percussion. If the artefact is symmetrical, the line will run from the centre of the base to the tip; the majority of tools are asymmetrical and the distal

point is likely to be to one side of the line. Then, using the set square, draw lines at 90° to the first, touching the top and bottom extremities of the piece (see Fig. 77). Trace the outline through the tracing paper as accurately as you can (using one line if possible), also putting in the ruled lines. If it makes it easier, stick the tracing paper down with masking tape. Reverse the tracing paper with the tracing to the right of the original, positioning it so that the two drawings are 3-6 mm. apart at the nearest point, the ruled top and bottom lines join up, and the vertical lines are parallel. Again, if you prefer, stick the tracing paper down and trace through using a retracted lead or a ball point.

The new outline may be quite faint, so go over it as before putting in the important points, but this time *use the first drawing as a guide* rather than the artefact.

Drawing in the facets

Still using a pencil, it is most helpful, and quickest, to begin by outlining the facets which are most easily seen when the artefact is placed flat on the page (next to its outline) and you are looking directly down onto it. This comes closest to the required orthographic view, and gives the maximum information for locating the starting and ending points for facets which are not so easily seen.

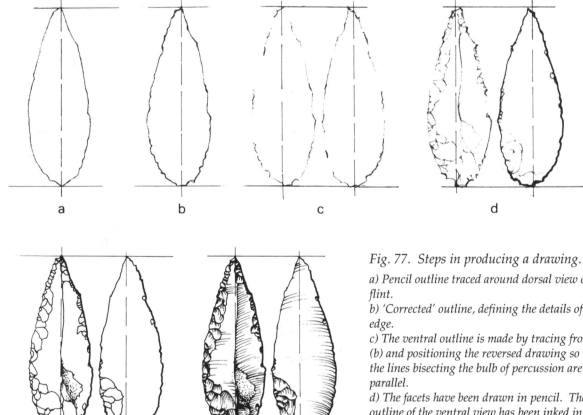

Fig. 77. Steps in producing a drawing.

a) Pencil outline traced around dorsal view of flint.

b) 'Corrected' outline, defining the details of the edge.

c) The ventral outline is made by tracing from (b) and positioning the reversed drawing so that the lines bisecting the bulb of percussion are parallel.

d) The facets have been drawn in pencil. The outline of the ventral view has been inked in, using 0.13 on the left (closest to the light) and 0.25 on the side away from the light source.

e) All outlines have been inked in, the facets have been drawn with 0.13, using the flint as a reference. The cortex has been shaded by dotting.

f) The completed drawing. The hatching is done in 0.13, observing the ripple characteristics from the actual piece and modifying the degree of hatching according to the angle of each facet.

Contrary to most drawing which you may have been previously taught you should now analyse perspective. If you are not at first confident about judging distances which are some way from the edge, use the set square and divider method (Fig. 76d and 76e).

For some facets the piece will need to be moved around under a light in order to see them well, and then you should interpret what you see to complete the drawing by using what you have already as a guide. If drawing a flattish piece there should not be any problems with foreshortening (except perhaps at the butt). Just remember, the steeper the angle, the more the distances are compressed in an orthographic view, and if an edge is rounded or undercut it may not be possible to see the complete outline of a facet. It can also be useful to reflect that if you have spent an hour or so looking intently at an artefact, the interpretation of the piece is likely to be as good as, or better than, anyone else's.

Inking in

Before choosing the nib size, the illustrator must be aware of the scale of reduction which will be used for reproduction of the final drawing. As a rule of thumb, the final (i.e. reduced) line size should not be less than 0.1mm. For a drawing which will be reproduced at the same size, use your finest technical pen (0.13 or 0.18) plus the 0.25. Always begin with the outline. Even something as subtle as an outline can communicate form, so use the finest pen to go over the top and left hand edges of both views i.e. the edges nearest to the top left 'light source'). Use the 0.25 to go over the right hand and bottom edges (the sides away from the light). Already the drawing will look three-dimensional (see Fig. 77d).

Then use the thinner nib to go over the outlines of the facets.

For the purpose of inking in, it is preferable to use the pencil drawing as a reference rather than a definitive statement, even for the outline. Pencil is less precise than ink and more responsive to the pressure of the hand. Also, the pencil drawing may be laboured, particularly if this is new to you and you are concerned to be accurate. Therefore regard the pencil drawing as a diagram and guide and the artefact as the real thing from which to produce the ink outlines. In a sense the process described above is being repeated, but without the initial pressure of concentrating on the length and direction of the ridges. So, draw from the tool itself, expressing its character and detail, using the pencil drawing as a basis. If a mistake is made it is easy to erase it with correction fluid etc.

From looking at publications it is possible to tell which drawings have been arrived at by simply going over the pencil (they have a uniformly smooth and bland quality), and which have been achieved by really looking at the artefact with the intention of expressing it.

For some publications (particularly those concerned with aspects of experimental technology and microwear) the archaeologist needs unshaded drawings, and it will not be necessary to do more than outline the facets and identify the form of the cortical areas by means of dotted shading.

Shading

Finer nib sizes are required - but remember that the final reduced line size should not be less than 0.1mm. (Technical pens, especially the thinner nibs, should not be regarded as an investment for life. If you do a lot of drawing, it is useful to have a spare nib in case of sudden failure.)

The shading of flints is usually regarded as the difficult bit, and it does sometimes require courage to begin, even for an experienced illustrator. Again, the golden rule is always start at the area where you personally feel the most confident, and where you can see the direction of the arcs clearly. Logically, the darkest areas, (those on the right hand and bottom edges) should be shaded first, because if the shading on the lightest (left hand side, nearest to the light) facets is too heavy, you may run out of the range of density possible to be

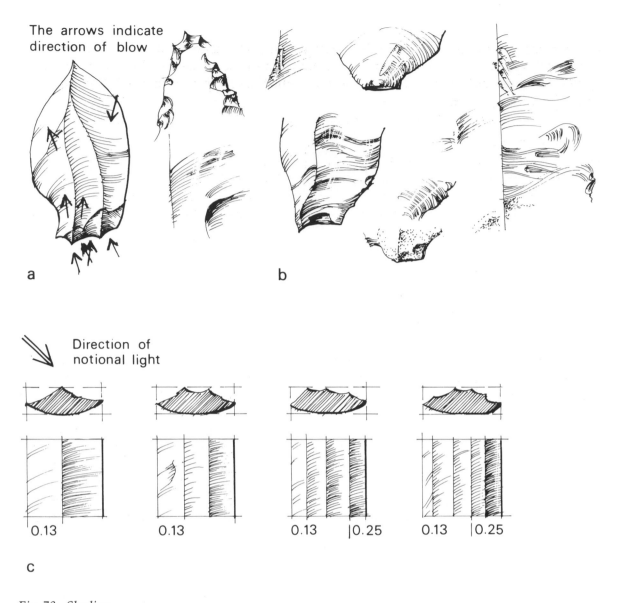

The arrows indicate direction of blow

a

b

Direction of notional light

0.13 0.13 0.13 |0.25 0.13 |0.25

c

Fig. 78. Shading.

a) Hatching follows the direction of blow, modified by the 'light' falling on the facet.

b) To best express the character of a piece, it is desirable to work towards a technique which combines accurate observation with freedom of line. This can only be done with practice, and (perhaps) inventing your own methods of conveying details and surface anomalies.

c) There is no golden rule about the density of shading. The final decision can only be made relative to a piece (or a group of pieces on one plate). It is preferable to use a thicker pen for large areas which require a darker tone.

reproduced for publication before one reaches the parts furthest away from the light source. It is worth repeating that the 'light' for illustrative purposes is conceptual; it should not be confused with the real illumination which may fall on the artefact. However, particularly at first, a close light source will be needed on your left to help identify the *relative* amount of shadow on the main facets, and this can be used as a guide for the rest. (If you attempt to shade the object as it really looks, even under a single, top left light source, as beginners often do, the drawing could end up (for illustration purposes) being very confused. This is because the surface of the flint is crystalline, and reflects and refracts the light.) The objective is to describe the essential elements of the facets. There is a convention that shading is in the form of an arc concentric to the point from where the blow was struck. However, since flint does not break evenly, perfectly concentric arcs are not created on the surface of the facets. The

actual 'rings' or 'ripples' of percussion are uneven arcs - tending towards concentricity. Individual ripples vary with the angle and direction of the surface and it is the diagnostic ripples which should be drawn to properly describe the suface of each facet. These must be ignored during shading.

Practising shading

If you have never used a technical pen before, get the feel for shading by drawing a freehand vertical line (on cartridge paper) and, starting at the right hand side of this line, using the natural movement of the wrist to produce an arc. This should be done quickly and freely, pressing down firmly at first and at the half way point taking the pen off the paper so that the line diminishes towards the end.

Shading the drawing

Guidance on shading is given in Fig. 78.

Drawing the other views

This section started with what are known as the 'plan' views, i.e. the dorsal and ventral faces. After that the most commonly required views are the profile(s), (side view(s)) and the butt or proximal view. For tools such as scrapers which have a lot of retouch on the distal (top) end, and cores, where a view of the top and/or bottom platform is important, these will also need to be reproduced. The principles are shown in Fig. 79 and 81 and Dauvois pp. 61 and 62. The main points to remember are that for views relating to the plan (the dorsal face), the tool is rolled from left to right; for the bottom end or proximal view the piece is swung downwards and outwards towards you, so that the dorsal face is on top and the ventral underneath, and this is put at the bottom of the plan. The distal end is swung upwards towards you so that the ventral surface is on top and the dorsal underneath; this view is put at the top.

Profiles

The profile occupies a rectangle made up of lines projected horizontally from the top and bottom of the plan and vertical lines which relate to the degree of curvature of the tool rather than its actual thickness (Fig. 79). The setting out (distance apart) of the vertical lines is best measured with calipers. It is important that the plan and profile views relate exactly so that any horizontal line projected from a feature on the plan views will cross that same feature on the profile (again see Fig. 79).

Even when these principles are well understood there is no quick and easy way of drawing profiles. If you are right handed, hold the piece on edge with your left hand and follow the edge with the pencil (Fig. 76c). A plasticine or card support can be used if preferred, together with a set square for marking out the edge (Fig. 76d and 80b).

Assuming you are still using the simple flake you started with, and two profile views are needed, select the flattest side or that which lies most nearly parallel with the 'backbone', and position it on the paper within the rectangle so that its extremities touch the outlines as you move your eye around the edges of the piece. It is remarkable how strongly perspective operates, even at short distances, and for this you should trust your strongest eye and keep it vertically over the edge you are looking at. Trace around the right hand side with the pencil, keeping your eye directly over the point where it describes the edge, reversing the tool and paper for the left hand side as described earlier. There is a tendency for profiles to be drawn thinner than they actually are, due to perspective, and dividers are useful as a quick check on accuracy for the main points on the outline.

The reverse view of the profile can then be positioned in its rectangle on the other side of the dorsal view using tracing paper. The main features may need to be "corrected" or "emphasised" as described for the plan views.

Profiles are drawn to give information about the edge of the tool which can't be seen on the plan, e.g. steep or undercut retouch, the degree of overall curvature, or the conformation of the edge relative to the dorsal and ventral faces. Let us assume only the edge is needed: draw this in on both profiles, if necessary drawing in the edge of the retouch at the butt as it appears on the profile (usually it looks like an upside down Y (Fig. 79)).

Inking in

No facets have been drawn, therefore the same principles apply as inking in the plan view outlines, i.e. for a 1:1 drawing a thinner pen for the left hand (lightest) side (0.13 or 0.18) and a thicker (0.25) line for the right hand (darkest) side of both profiles. The line of the edge, the most important, is drawn thicker (0.35). Again, when the final version is to be 1:2, remember to double the size of the nibs on the original drawing.

Proximal and distal views

The principles are the same as for the profiles. The guide rectangle in this case is formed by lines projected from the widest part of the dorsal view and the overall thickness of the profile (Fig. 79a). Rather than attempting to draw around an outline which may be 2"-3" away from the surface of the page it is better to project from the dorsal and profile views to identify the main points where the outline touches the rectangle and connect them, referring to the tool as a guide to the angle and degree of curvature of the connecting lines. The butt is the view most usually required. Where necessary, the distal view can be duplicated from the butt. The retouched area of the butt, and distal end, are outlined in a heavier pen.

Drawing in the facets

Examples of completed profile, butt and distal views are shown in Figs. 79a and 79b. Often the facets required to be shown are confined to those areas of retouch which can't be seen clearly from the dorsal or ventral face, e.g. the surface of the butt or the 'backing' of a backed blade. These are usually shaded, and the major facets on the other faces shown in outline (Fig. 86). As the facets are small it is easier to hold the piece in your hand, moving it around when necessary under the light, rather than attempting to look directly over it when placed on the table.

It is easily possible to lose your place when drawing retouch in profile, due to the length and subtle changes of direction of the edge; therefore project lines across from the major features of the edge on the dorsal view as a guide, dividing the series of facets into groups. Foreshortening occurs as the edge goes away from you, so that what in plan is a large facet may appear very narrow in profile, or indeed may be completely hidden. Draw in one group at a time, as usual starting with the aspects which are most easily seen. The tiny facets at the edge may be (technologically) as important as the others so these (as far as possible) should also be put in.

When shading, the most important aspect is the direction of blow, followed by the communication of the angle and depth of the facet.

Having read this far you will know the basic techniques of stone tool drawing. The following deals with other commonly encountered aspects, drawing conventions and refinements.

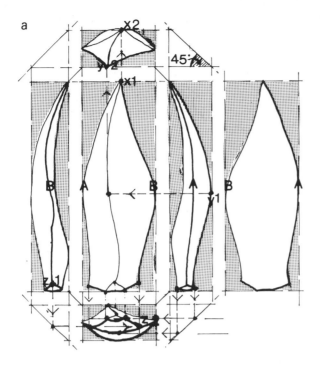

a) *Layout and relationship of views.*
Points on the end views can be located by projecting across from others, eg:
x1 - x2 distal points from dorsal view
y1 - y2 highest point of profile projected across to the dorsal view and up (or could be down) to the end view.
z1 - z2 right hand edge of butt is projected down to 45° line across to meet with line dropped from dorsal view.
Note also how the thickness of the butt was arrived at. In practice, much of this can be done by eye, but it is necessary to understand the basic principles when dealing with complex pieces - and as a check on your accuracy.

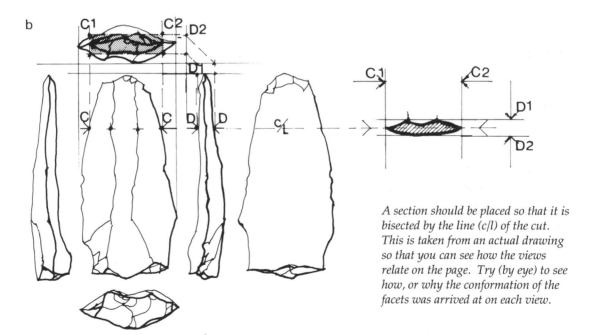

A section should be placed so that it is bisected by the line (c/l) of the cut. This is taken from an actual drawing so that you can see how the views relate on the page. Try (by eye) to see how, or why the conformation of the facets was arrived at on each view.

b) *Constructing a section*
The 'box' containing a section for any given point is determined by the width (C) and the thickness (D), at that point. It is the view you would have if the flint were cut across and you were looking end-on at the upper piece. A section is put 'the right way up' in relation to the line of the cut (c/l) as shown. The dimensions of the box can, of course, be measured directly from the flint, and other aspects (facets etc.), taken from the relevant drawn view using dividers.
If you find these diagrams difficult to understand at first it is worth persisting, as they are based on common sense. When you come to realise how they work it will give you control over the positioning of your drawings on the page.

Fig. 79 *The relationship and construction of required views.*

Drawing more complex tools

The archaeological environment in which you happen to work may demand, and therefore develop, your expertise in a particular typological series which other illustrators may seldom be asked to draw. This expertise should therefore be developed. For all tools however, the principles and conventions remain the same, and if you are familiar with them you need not be daunted by an unfamiliar type. For an example of a more complex piece a blade core has been chosen, as it presents a number of the 'difficult' aspects which may be encountered.

Drawing the outlines

A blade core is roughly cylindrical although it usually has a 'front' and 'back', determined by the degree of working; the back frequently shows cortex and may be flatter. It may have a single 'top' platform, or be a double platform core in which case blades will have been struck from both ends. The larger platform is regarded as the top. With such a piece, it may be required to draw six views: horizontally the right hand profile, front, left hand profile and back (rolled from left to right) and the top and bottom platforms positioned respectively above and below the front view (Fig. 81). The drawing therefore requires three outlines which will be duplicated using tracing paper as described.

The horizontal views

For all of these the process is the same although the datum should be the most important, i.e. 'front' view. This determines the upper and lower lines within which the profiles fit (Fig. 80a). Cores are unwieldy and can need support in both lateral and vertical planes relative to the backbone or axis. Start with the supported front view towards you and mark off the edge at regular intervals (approx. half an inch, also determining the main features) using the hinged set square (Fig. 95 and Dauvois p. 93). Then, with your strongest eye above the edge, trace around the outline joining up the points marked. You may not at first believe what you see, as the perspectival mode of vision is so strong, and you will find that you need to move your eye constantly to remain over the tip of the pencil.

The procedure is the same for the profile, which should be positioned so that the top of the front edge touches the horizontal line projected from the top of the front view (Fig 80a). The bottom edge should then be swung round until it touches the bottom line; it is likely that the top platform will be tilted backwards. When marking out the edge, identify the limits of the platform(s) as this will help to align the drawings correctly.

End views

The front and profile determine the rectangle for the end view outline. The front and back edges of the top platform can also be projected onto the rectangle (using your 45° set square) enabling that view of the core to be correctly aligned (see Fig. 81a). Because a top view is that most often required, it is preferable to draw end view outlines from the top, whatever the actual shape. In this position most cores are too heavy to be supported by plasticine, and can be held with your left hand while drawing the outline (as described for flake profiles above). If you do not feel happy with this idea, make a cruciform card support, using the first two views as a guide for the cut-out (see Fig. 97) and follow the edge-marking procedure. You now have all the outlines you need.

Dauvois suggests using a profile gauge (Dauvois p. 100) to obtain a profile view of a biface. If you find this method most helpful in providing a rough guide for an outline, then use it. However, the prongs tend to slide on the surface of the tool, and it can be a problem to keep the gauge exactly in place for the outline required.

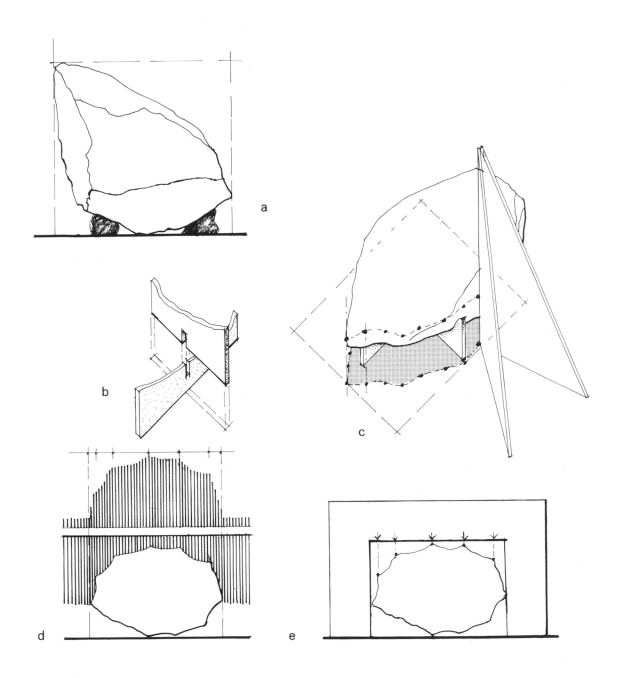

Fig. 80. Drawing a core - established edges and points.

a) The core is supported by plasticine. Imagine you are looking down onto the front view. The outline can be established either by eye (as in Fig. 76c) or by marking out the edge at intervals as shown below, and joining the points by eye. The dashed line shows how the profile view would relate to the front view as seen from this position.

b) A card support can be used as an alternative to plasticine for an awkward shape.

c) Establishing edge points with a set square.

d) A profile gauge may be used to obtain a (rough) profile or to obtain ridge points (cf e)

e) A piece of card can be placed over the piece at a particular point to give information about the facets at that point. (This derives from the same principle as drawing sections, as in Fig. 79b).

Drawing the facets

The area to watch is at the sides, where the form drops sharply away. Time usually being a constant pressure for illustrators (particularly those working free-lance) training your eye to be accurate, rather than relying on mechanical means, is the goal to be aimed for. In the meantime use them as a check on what has been done. For the nervous here are three suggestions; they all require manual dexterity.

1) The set square and divider method, as described in Fig. 76c, mainly for the front-facing facets, the foreshortened ones must fit into the remaining space (even if one doesn't believe it).

2) Using a profile gauge and projecting from the points obtained (Fig. 80d). This is similar in principle to:

3) Making a card bridge over the piece then projecting lines up onto the edge of the bridge. These can be used as markers across the front view (Fig. 80e), but only for the point on the tool where the bridge has been placed.

All the views work together (Figs. 79 and 80), therefore points established on any view can be projected as guides.

A method which can be helpful if faced with a projection run of large and complex pieces which need to be drawn quickly is to use a glass screen. This enables you to look directly down on the object and trace the main features onto transparent film. It is easily possible to make your own version, the simplest being a piece of glass (with polished edges) supported on corner blocks; a picture frame might be a suitable basis as the blocks could then be screwed or glued to it. The tool needs to be supported as close to the glass as possible to eliminate the distortion caused by head movement and perspective, for this reason the device works best with flattish pieces, e.g. pressure flaked tools or bifaces. Transparent film will be needed, such as that produced for use with overhead projectors, and a fine spirit-based marker. (You will not be producing a finished drawing but an accurate guide.) Trace the pencil outline already made onto the film, (this is more accurate than copying through the glass), position it over the tool, and stick it down. It will not be possible to see every facet and anyway, it is better to leave the finer detail as your pencil drawing will be more precise than the marker pen. Then trace the drawing back onto the cartridge paper outline using a light box, or failing this a suitable window, and carry on as before.

This might seem laborious as it creates an intermediate stage in the process, however it will be quicker and less stressful and messy if you are under pressure or having a crisis of confidence.

Inking outlines and shading

With thicker pieces it is necessary to increase the range of pen sizes, depending on complexity. For the outlines of large pieces it is preferable to differentiate more strongly between 'light' and 'dark', using 0.35 for the dark side and 0.13 for the light outline and facets.

For shading a 0.13 (or 0.18) is too fine to achieve all the gradations necessary for a thick tool, as the lines would run together in an indistinguishable mess on the published drawing in the dark areas. Therefore before you begin (and depending on the form of the piece), decide which facets should be 'lighter' or 'darker' (shaded 0.13/18 or 0.25) or, perhaps with something as thick as a core which should be light, darker and darkest (0.13/18, 0.25 and 0.35). This is shown in Fig. 81b. There is no need to make an absolutely definitive decision at first go; if in doubt err on the side of 'lighter'. It is always possible to beef up shading with a thicker pen, and interposing 0.13 lines after putting in 0.25 or 0.35 shading on the darkest areas can add definition and subtlety to the form of a facet. Similar principles apply when dotting in the cortex.

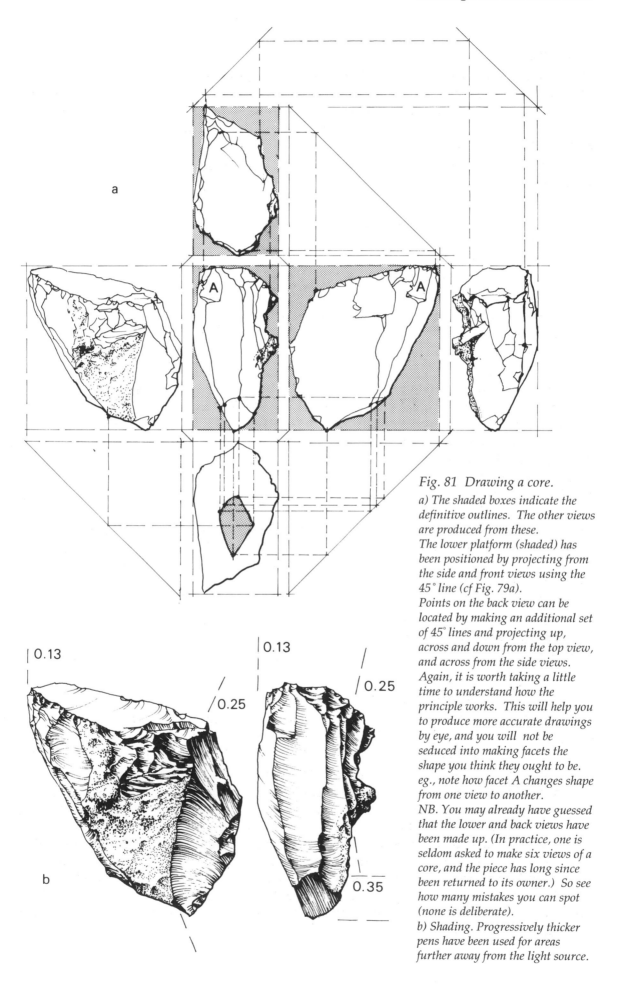

Fig. 81 Drawing a core.

a) The shaded boxes indicate the definitive outlines. The other views are produced from these.

The lower platform (shaded) has been positioned by projecting from the side and front views using the 45° line (cf Fig. 79a).

Points on the back view can be located by making an additional set of 45° lines and projecting up, across and down from the top view, and across from the side views.

Again, it is worth taking a little time to understand how the principle works. This will help you to produce more accurate drawings by eye, and you will not be seduced into making facets the shape you think they ought to be. eg., note how facet A changes shape from one view to another.

NB. You may already have guessed that the lower and back views have been made up. (In practice, one is seldom asked to make six views of a core, and the piece has long since been returned to its owner.) So see how many mistakes you can spot (none is deliberate).

b) Shading. Progressively thicker pens have been used for areas further away from the light source.

107

Cores also demonstrate two further kinds of undercutting:

Cores also demonstrate two further kinds of undercutting :

1) Immediately under the top edge where the bulb of percussion of a detached flake leaves its negative impression (complicated often by retouch).

2) On facets at the extreme left hand side of a view. These may be so angled that the light will cast a shadow towards the left (i.e. on these facets the pen will move from right to left to make the shading arcs rather than the usual direction of left to right).

Both of these are shown in Fig. 98.

The main conventional symbols (Fig. 82)

These extend the range of technological information communicated by the drawing. The illustration is based on Dauvois, Fig. 29. Of the symbols shown, 1, 2, 5-7, 8 and 11-14 are those most often needed.

1) The direction of debitage (the direction from which the original flake was struck) is indicated by the arrow; the bulb of percussion has been removed.

2) The arrow indicates the direction of debitage. The butt and bulb are present. This is mostly used in cases where a drawing of the ventral face would not be particularly informative but the direction of debitage is not that which you might expect from the dorsal view, e.g. one where the tool is (correctly) shown with its working edge uppermost but the retouch forming the scraper has been made on the proximal end. If no such arrow is present, in the absence of a ventral view it is assumed that the tool has been drawn with the butt at the bottom.

3) Linked arrows indicate a double bulb of percussion, an 'accident' of debitage which is rarely seen.

4) The butt (point of impact) has been removed by retouch. The arrow indicates direction of debitage.

5) The arrows indicate the direction of burin blows. The letters and numerals show sequence of removal.

6) Long dashes show an 'old' break close to or contemporary with the archaeological period of the tool.

7) Shows an ancient break on the distal end and a recent (short dashed) break on the proximal end.

8) The unshaded facet indicates that it is not related to the manufacture or use of the tool but caused by later geological or mechanical damage.

9) In lieu of shading, the arrows indicate the direction and sequence of debitage in this case (forming a Levallois flake).

10) Shows sequence of retouch by pressure flaking.

11) The dots indicate that the edge has been blunted and the cause (use or accident) has yet to be determined. The size of dot indicates the thickness of the blunted edge.

12) The dotted areas both on the tool surface and alongside the edge indicate 'polish' caused by using the tool. Most often this is the result of use with vegetable material (e.g. silica gloss or polish associated with cutting grass-related plants). Microwear analysts have described polishes associated with other materials (bone, meat, wood, etc.) which are not visible to the naked eye. If you are working with a microwear analyst they should indicate how they want the polish to be illustrated. Dotting has become the convention for silica polish, but the other types have not yet established a suitable symbol. With microwear, perhaps all you will need to demonstrate is where along the edge the polish has been seen; the various permutations of a dashed line should give you sufficient scope to show different polishes, if they are required.

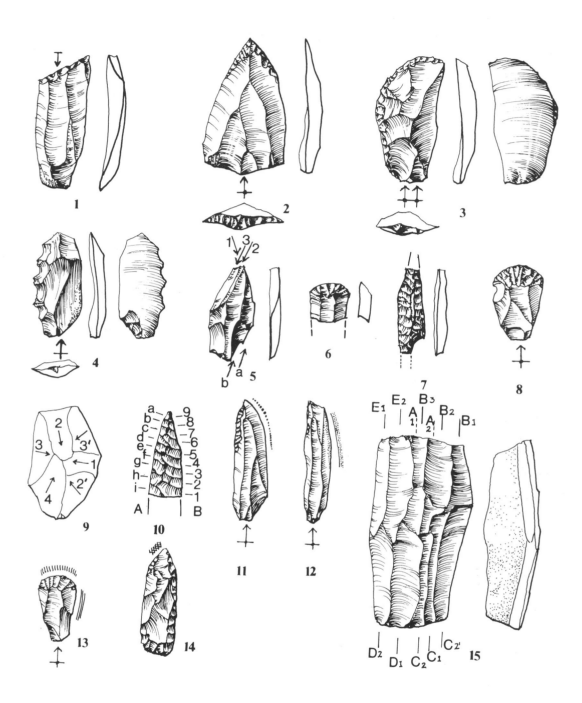

Fig. 82 The main conventional symbols

13) Abrasion caused by repeated use of the tool in the same direction; the lines indicate the direction of use. For the end scraper illustrated, the distal end shows wear associated with pushing the tool upwards away from the user; the right hand side shows wear in the same direction.

14) Cross-hatching indicates generalised rubbing or abrasion. This might also, if sufficiently obvious, be shown on the drawing.

15) This shows the sequence and direction of blade manufacture on a double platform blade core.

Enlarging and reduction

Stone tools are normally drawn full size and reproduced 2:3 full size in publication. For very large or small pieces it may be necessary to produce your finished drawing at a different scale, for example microliths are usually shown x2 full size. Any alteration to scale should be made after the outline and facets have been drawn in pencil; the thickness of the ink lines should be compatible in the publication with objects originally drawn full size. The most accurate method is to use a Grant enlarger, tracing the enlarged or reduced pencil outline back onto cartridge for inking. If you do not have access to this kind of equipment, the next best alternative is a photocopier which scales up or down in the correct ratio. Failing this, use squared paper and redraw the object at the new scale. A pantograph is sometimes suggested for this operation but this requires constant measuring and will be more time consuming and less accurate than the other methods described.

Special cases

a) Microwear analysis

If you need to draw a tool immediately but it is going to be sent for microwear analysis, touching the edge should be avoided under any circumstances. Archaeologists will be prepared to sacrifice accuracy of detail for an edge untouched by lead, wood, metal, paper, fingers etc. The illustrator's problems relate mainly to the outline. Support the tool so that all edges are raised slightly above the paper and, with the pencil at an oblique angle away from the tool, trace around the edge turning the paper if necessary (similar in principle to Fig. 76c). If you keep your eye directly over the edge you will be able to see when the point goes underneath or comes away from the outline. Then correct the drawing.

Fig. 83 Refits

a) A reassembled archaeological piece. Two burins have been made from the original tool. The profile has been closely fitted, therefore it is both shorter and in an unconventional position on the page relative to the loosely fitted dorsal and
b) A refitted experimental piece. In this case it was more important to show the pattern of breakage than the shading.

b) Refits

There are two main situations where it may be important to show how pieces of flint fit back together:

1. In an archaeological context, which can range from a simple break to the reconstruction of a core from the debitage recovered.

2. In experimental archaeology, where aspects of tool morphology are being reproduced, e.g. typical patterns of breakage due to use.

In both cases you should ascertain exactly what the archaeologist wants to show, and how this can best be done. For example, it may be appropriate to draw the pieces closely refitted in outline, plus exploded views of the dorsal and ventral faces which are shaded to show reworking after debitage etc. Each situation should be approached individually (examples are shown in Fig. 83).

Developing expertise and drawing atypical pieces

It is possible to produce an informative and satisfactory drawing without having any pretensions to art. To show the outlines of the facets, the direction of debitage and the form correctly, is the main aim. A pair of compasses or a template (e.g. French curves) can be used to produce shading mechanically but, on the printed page, there is a clear difference between drawings which are 'informative' and those which also express the character of the piece and the texture of the stone the tool has been made on. Flint has an aesthetically pleasing surface quality which, as it happens, is particularly amenable to reproduction in ink line, and the illustrator can both exploit and enjoy this during the process of drawing. There are discoveries the individual illustrator can make which will add to our knowledge not only of drawing, but of stone tools, as drawing is at present the most potent means of the visual communication of artefacts. Therefore the information given in drawing manuals should be seen as a stepping-off point rather than a track which must be slavishly followed. The conventions and symbols are there for good reason, as a basis for common understanding; discussions of techniques and processes become more interesting as one gains expertise and experience.

An aspect which is met with constantly is description of surface. This cannot be separated from form as there is only one method of describing them graphically, that is by shading and, as we have seen, the shading also provides precise technological information. To go beyond the mechanical reproduction of basic information (direction of debitage and angle relative to light), it is necessary to observe and interpret, always bearing in mind clarity of reproduction.

a) Surface character

Each facet has its own pattern of ripples: fine, deep, close together; broad and shallow; distorted from a perfect arc even to the extent of curving in the 'wrong' direction. These can be shown by manipulating the grouping, density and direction of shading, and where the facets show local undercutting the shading may originate from the right hand rather than left hand edge. Rays and tearing, where a facet breaks up at the edge, should be shown for what they are, i.e. tiny facets. It is not necessary to put a line all the way round them, shading alone or a line on the edge nearest to the light is sufficient (Figs. 78b and 84a).

b) Abraded areas or granular surfaces (e.g. cortex) do not always have cleanly edged facets but a rounded hump rather than a sharp peak. In this case the facet should not be outlined in ink; the initial pencil line will indicate where the concavity of the facet begins to fall away more steeply, and you can begin ink shading from the pencil line, which is then rubbed out (Fig. 85b).

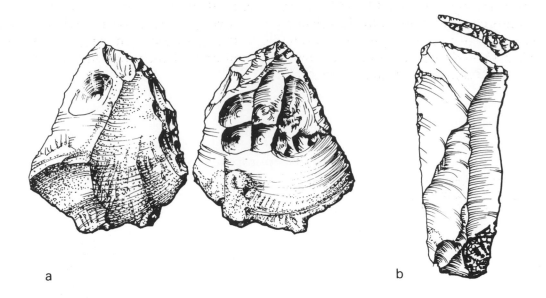

a b

Fig. 84 Thermal damage.

a) A moderately severe case of frost damage which causes potholes on the surface. These should be shaded from observation of the characteristics of the individual holes.
The tool was made on a cortical flake which also demonstrates 'tearing', inclusions or larger grains have interrupted the force of the blow. Normally such tears or streaks point towards the centre of the blow.
b) Fire damage.The surface of the tool has been taken off, leaving an irregular, crystalline surface at the lower right hand side.
Note also that the view of the truncation to the distal end has been placed parallel to its angle.

c) Acute angles on thick pieces can present problems of definition. On the left side, supposing a trapezoidal section, the highlighted area for illustration purposes will be the top left hand edge. Below that point the facets which slope towards the left should therefore be shaded mainly from right to left. On the right, however foreshortened the angle of each facet or detail may be, the edge of every change of angle/facet should be highlighted; the notional light source can be infinitely manipulated to describe form (Fig. 81b). The proximal end should be treated in a similar fashion to the right side but, in general is relatively darker. Where the distal end is thick and more or less parallel to the angle of view, as in core platforms, imagine the ripples and facets as a series of hills. Very little shading is needed, but the outline of each hill can be thrown into relief against the one behind it by delicate shading at the lower edges, more on the right than the left .

d) Thermal damage

Extreme heat and cold create characteristic surface erosions. Fire damage is perhaps more interesting for the archaeologist, so it is drawn more frequently. It causes surface crazing of the flint, sub-circular holes, and can remove areas of the surface leaving rough, crystalline patches. Surface crazing is not, unless extreme, usually drawn. The holes are shown by shading them as indentations of varying depth; they do not normally have any of the arc-like characteristics of a struck facet (unlike frost damage). The crystalline areas should be shaded to represent them as closely as possible, using a combination of closely grouped parallel lines on the dark side of the crystals and dotted shading to show the overall conformation; the ghosts of retouch can sometimes be seen. Alternatively the archaeologist may prefer that these areas are left unshaded.

Frost damage causes pot holes in the surface, singly or in groups, and normally each (more or less circular) indentation has clear concentric rings. Single holes should be treated like facets with an outline (a light one) and shaded with arcs following the rings. For a group, the outline should delineate the whole area, and within that each indentation should be treated individually, cf. "abraded pieces" above.

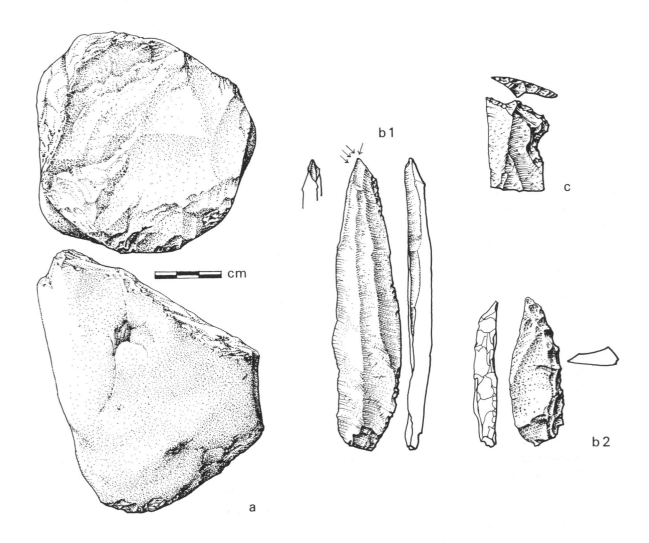

Fig. 85. Stone other than flint.

a) Shows a hammerstone made from a quartz galet or pebble. In shape it resembles a core, and the upper surface appears to have been worked, although no arcs are visible, as quartz tends to fracture in an angular manner. The drawing attempts to show the difference between natural (rounded), abraded (chipped through usage) and 'worked' or knapped surfaces. Dotting was the only means of conveying the surface quality in this case.

b) Both pieces are made on chert. b1) shows a burin made on finely grained chert. The arcs are indicated by fine horizontal lines continued by dotting. (This drawing also demonstrates that it is not always necessary to put in full profile - only the parts which are of typological interest need to be drawn.

b2) shows a side scraper made on coarser chert. The drawing attempts to convey this by using heavier and more diffuse hatching supplemented by dots. The profile shows the 'hard' outline of the facets, using line, necessary for understanding its manufacture. The dorsal view shows how soft the edges of these facets appeared relative to the overall form.

c) Jasper. This has a duller surface than flint although it behaves in the same way. It is characterised by small, dark inclusions. The best way to deal with these is to draw them in directly from the piece, using them as an aid to creating form.

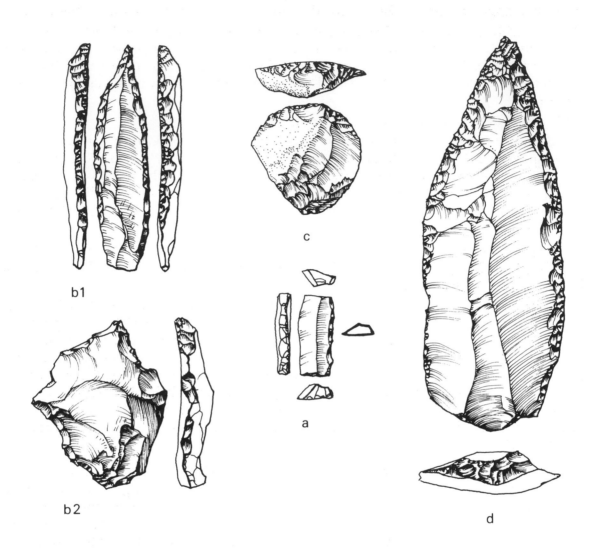

Fig 86. Typical illustrations

It is not usually necessary to show all of the possible views, or to show each view shaded. These drawings are typical of published illustrations.

a) Is a truncated piece made from a bladelet, only the dorsal view has been shaded but the archaeologist wants to illustrate the facets at each end and the steep retouch to the right hand side.

b1) It has been necessary to show the thickness of the piece and the steepness of the retouch required to make the point at the distal end. For clarity, all of the retouch on the profiles has been shaded.

b2) On this piece important retouch could not be seen from the dorsal view. Some of the facets at the left hand edge have been very much foreshortened in profile, even so they were required to have an understanding of the tool.

c) The dorsal and distal views of a scraper have both been fully shaded. The bulb of percussion is indicated by the position of the dorsal view.

d) A typical dorsal and butt view. There are two unshaded facets on the dorsal face, indicating that they are 'damage', and/or not contemporary with the original manufacture of the piece.

e) Describing stone other than flint

Tools utilising other types of stone fall into two general groups for illustrative purposes :

 1) Pieces which have been shaped by knapping, in which case the general principles of flint illustration apply, but are modified according to the surface characteristics of the stone.

 2) Tools which, for want of a better word, could be describes as 'monolithic'. These have a generally smooth surface and may have been shaped by usage, e.g. grindstones of various kinds, or natural pebbles used as hammerstones. Some artefacts are shaped by polishing, e.g. Neolithic celts (axes), although the indications of debitage are not always completely removed.

For 1) the treatment depends on the surface quality :

Obsidian is natural glass, very smooth, and demands an intensified version of a flint drawing; the highlights should be made lighter and the darks darker than with flint; this emphasis should be left up to the illustrator with regard to the publication which is being worked on. If all the tools are of obsidian, then there is no pressing need for differentiation. If some are obsidian and some flint, then it is useful for the reader to be able to identify which is which on the page.

Jasper is duller than flint and has characteristic surface blotches which can be illustrated using tiny groups of parallel lines (Fig. 85c). Always look at the piece as a guide for adding these to the shaded drawing.

Chert, quartz and other coarse-grained stones have softer contours than flint; the ripples from the point of impact take longer to travel through the material. The edges of the facets may not have the same clarity as flint, and if this is the case should not be given an ink outline. Some facets may be sharper edged than others; often the secondary retouch has greater clarity; here it may be appropriate to put in a full or partial outline. When shading, the arcs can be shown as broken or dotted lines (Fig. 85 and Dauvois Fig. 17). With experience, the illustrator will build up a personal method of reproducing variations in surface texture, using a combination of direct observation and the conventional light source to produce a rendering which conveys the feel of the surface.

For 2) the form is generally expressed by dotted shading. The pen size to use depends both on the smoothness (grain size) of the surface and the steepness of an angle as it drops away from the viewer. For example a Neolithic celt (stone axe) which is rectangular in section with rounded corners, may have been made on a fine - grained stone. To express the grain and smoothness it would be appropriate to use a 0.13 or 0.18 nib, but for the central hole, right hand side and lower edge it may be better to use 0.25 or larger, as the dots should not run together. Fig. 85a shows a hammerstone, which has a generally smooth surface with abraded areas where it has come into contact with the object being worked on - it also seems to have been 'knapped' on the top surface.

Colour

Exceptionally, if a piece shows evidence of having come into contact with ochre, you may be asked to indicate this. Commercial red inks are available for use with technical and dip pens, and these can be used if the drawing is for display or record purposes. If the drawing is for reproduction, the red areas must be put on a separate sheet of tracing paper or film, in black ink. Both the overlay and the main drawing must then have register marks (e.g. crosses) placed near the corners in order to locate the red overprinting in the correct place. See Dauvois p. 230, Fig 66.

Conclusion

Drawing stone tools is very satisfying. It is not necessary to be an expert in tool technology, although more knowledge will be gained as time goes on. It is, however, necessary to combine an understanding of the conventions of illustration with accurate observation. This comes with practice and increasing confidence. It is hoped that this will give you a basis for the enjoyment of drawing stone tools.

Mounting and finishing

Warning : Some adhesives and correction fluids contain solvents which may be harmful if absorbed through the skin or inhaled as vapour. Appropriate precautions including the use of a well ventilated workspace must be taken.

Pasting-up

Some modern photocopies are of sufficiently good quality to be sent to the printers instead of the actual drawings. This can be very useful if the drawings are likely to be wanted again.

Whichever is being used, originals or copies, the artwork is first cut out from the paper with scissors, leaving as few straight edges as possible and not coming within 1 cm. of the drawing. These loose drawings are then arranged on a sheet of white mounting card, marked in blue pencil with the outline of the eventual print area, multiplied by two, three or four times, depending on the degree of reduction chosen. The dimensions of the print area should be checked at this point; remember to allow space for the figure's printed caption.

It is important when arranging pottery drawings to ensure that the centre lines are all vertical. It may be helpful to draw a blue pencil guide line vertically down the centre of the mounting area, and also one or two horizontal guide lines, drawn with T-square and set square. The resulting grid can be useful for aligning drawings.

All lines, marks, notes and numbers drawn on the drawings or card at this stage should be made with <u>blue</u> pencil. The drawings are photographed onto line film (see p. 2), and blue is the one colour that does not register on the negative. It will reproduce on photocopies as they involve a different photographic process.

If a drawn scale is required, it should be prepared and included with the drawings. These are now laid out within the print area outline, and moved around until the best arrangement is arrived at. Draw round the pieces of paper with the blue pencil to fix the exact positions. The loose drawings can then be removed and the adhesive applied. "Cow Gum", a rubber solution, is often the preferred adhesive though other similar products are available. A well ventilated working space is essential. If the gum is applied to the mounting card only, the drawing will be fixed in place very quickly; if the adhesive is applied both to the area of the mounting card marked for the drawing <u>and</u> to the back of the drawing, the adhesive stays "wet" for some time, allowing the drawing to be adjusted or repositioned, or removed. If tracing paper or drawing film is to be mounted on card, it is best to tape it down with "Magic Tape", rather than use adhesive. Film does not absorb adhesive and will fall off once the adhesive dries; tracing paper may well wrinkle, and will certainly turn brown after a few months (and drawings may well await publication for many months!). This 'browning' can be dark enough to reproduce as a black mark. After a couple of years, the 'brown' tracing will simply fall off the board!

Although "Cow Gum" and similar rubber solutions are a little messy, surplus adhesive can be easily removed once dry; the best way is to make an eraser from the solution itself. Simply take a blob of the solution and allow it to dry, for example, on a tin lid. It will then easily remove surplus adhesive (when dry) from drawings and mounting card.

Once the drawings are firmly in place, and surplus adhesive has been removed, it is advisable to paint round the edges of the paper with "Process White" or white poster paint; not too liquid, as this will wrinkle the paper. If tracing paper or film have been taped onto the board, it is probably best to use "Tippex" for this task. The white paint helps to prevent the edges of the drawing paper reproducing as faint lines.

Numbering

Whilst blue pencil numbers will suffice during the mounting-up, the artwork will obviously need black numbers for publication. These *can* be put in by the printer, but mistakes can and do happen, and it is far better for the illustrator to present the printer with a completely finished ("camera-ready") piece of artwork. Numbers can be stencilled onto the sheet with plastic stencils and a suitable pen, or can be more easily put on using one of the various "rub-down lettering" brands. The original one of these was "Letraset", but some illustrators prefer the more recent makes "Mecanorma" and "Chartpak". It is advisable to rule faint blue guide lines with the T-square to ensure even lettering. Once in place it should be burnished down; place the backing sheet over the number, and burnish it using a finger nail or the top of a ballpoint pen, if smooth. The manufacturers of lettering sheets sell "burnishing tools" but these do nothing that can't be done with a finger nail or pen cap.

The sheets of lettering are arranged by typeface and in order of printers' type sizes, e.g., 8pt., 14pt., 24pt., etc. Choose a typeface that is clear and simple, e.g., Berling, Helvetica or Univers, and a size that will reduce to the same degree as the drawings and still be legible. 1mm. high is the smallest legible size, and 1.5mm. - 2mm. is a better size for easy legibility.

Most manufacturers produce useful catalogues of their typefaces and available sizes and these are well worth obtaining; bear in mind that American and European type sizes are not the same, e.g., American 14pt. is not the same as European 14pt.

The lettering can be sprayed lightly with a sealant spray to fix it, though this is not absolutely necessary for drawings mounted on card, since this is unlikely to flex. Any numbering applied to paper or film which may be rolled up should be fixed with the spray.

Unless specificially instructed, it is not necessary to letter a heading, e.g. "IRON OBJECTS" onto a sheet; all titles and descriptions are normally left off, and can be dealt with in the printed caption.

Finally, tape a cover sheet of thin layout paper over the artwork to keep it clean *en route* to the printer.

Marking the finished sheet for the printer

It is often left to the illustrator to mark up the finished artwork with instructions to the printer. This is done with blue pencil on the top or bottom margin of the sheet and is usually in the form: "Please reduce to 1:2 linear" (or 1:4 or whatever the appropriate reduction may be). The term "linear" is important, as 1:2 linear (i.e. measured along one edge of the print area) is very different from 1:2 area, i.e. 50% of the print area. If the artwork is to be reduced to a specific width or height rather than to an exact size, (for example to fit the print area of a particular journal, which may not lend itself to an exact reduction) a different system is used. In these cases, draw a horizontal blue pencil line across the bottom margin of the mounting card; at each end a short blue pencil vertical line should align with the outermost point of the artwork at each side. Along the horizontal line, write in blue pencil "Please reduce to exactly 13.5 cms. wide" or whatever figure is appropriate for the particular journal or book. Where the vertical reduction is the important one, the same procedure can be used vertically in a side margin.

If any illustration is to be published without numbering or other lettering, it is advisable to mark the sheet with "This way up" or "Top" (at the top!) with an upwards pointing arrow; never assume the printer will know the right way up.

In all cases care should be taken to check the proofs that should be sent from the printer to the author before publication. If artwork has been clearly labelled for reduction to 1:2 (for example) and comparison of the proof with photocopies or the original artwork shows any inaccuracy, it should be returned to the printer to be redone, at the printer's expense.

Bibliography

General Bibliography: techniques and materials

Adkins, L. and Adkins, R. A. 1985 Radius Curves Without Tears, *The London Archaeologist* Vol. 5, No. 3, 79-80.

Barker, P. 1977 *Techniques of Archaeological Excavation*, Batsford.

Dillon, B. D. (ed.) 1981 The Student's Guide to Archaeological Illustrating, *Archaeological Research Tools* Vol. 1, Institute of Archaeology, University of California, Los Angeles.

Brodribb, C. 1970 *Drawing Archaeological Finds for Publication*, John Baker.

Crummy, P. 1987 *Reducing Publication Costs*, Institute of Field Archaeologists Technical Paper No. 6.

Hope-Taylor, B. 1966 Archaeological Draughtsmanship: Principles and Practice, Part II, *Antiquity* XL, 107-13.

Hope-Taylor, B. 1967 Archaeological Draughtsmanship: Principles and Practice, Part III, *Antiquity* XLI, 181-9.

Kefrey, L. 1984 The Reluctant Draftsman Displayed: some notes for occasional draftsmen, *The London Archaeologist* Vol. 4, No. 15, 408-10.

Kenrick, P. 1971 Aids to the Drawing of Finds, *Antiquity* XLV, 205-9.

Maney, A. S. 1980 *The Preparation of Archaeological Illustrations for Reproduction,* Association of Archaeological Illustrators and Surveyors, Technical Paper 1.

McCormick, A. G. 1977 A Guide to Archaeological Drawing, *Notes for Students,* Department of Archaeology, Leicester University.

Piggott, S. 1965 Archaeological Draughtsmanship: Principles and Practice Part I, *Antiquity* XXXIX, 165-176.

Porter, T. and Greenstreet, R. 1980 *Manual of Graphic Techniques 1,* Astragal Books.

Webster, G. 1963 *Practical Archaeology,* 155-66, A and C Black.

Examples of different illustration styles:

Objects

Brailsford, J. W. 1962 *Excavations at Hod Hill I,* British Museum.

Bushe-Fox, J. P. 1949 *Richborough IV,* Society of Antiquaries.

Clarke, G. 1979 The Roman Cemetery at Lankhills, *Winchester Studies*, Vol. III, Part II.

Cowgill, J. *et al.* 1987 *Knives and Scabbards,* Museum of London.

Cunliffe, B. W. 1968 *Richborough V,* Society of Antiquaries.

Kenyon, K. 1948 *Jewry Wall, Leicester,* Society of Antiquaries.

McWhirr, A. D. 1982 *Cirencester Excavations I, Cirencester Excavations Committee.*

Pitt-Rivers, Lt. Gen. A.H.L.F. 1887-98 *Excavations in Cranborne Chase*, Vols. I-IV.

Wheeler, R. E. M. 1943 *Maiden Castle.,* Society of Antiquaries.

Textiles

Hald, M. 1980 *Ancient Danish Textiles from Bogs and Burials,* The National Museum of Denmark Archaeological - Historical Series Vol. XXI.

Schmedding, B. 1978 *Mittelalterliche Textilien in Kirchen und Klöstern der Schweiz,* Schriften der Abbeg-Stiftung, Bern.

Walton, P. and Eastwood, G. 4th ed. 1988 *A Brief Guide to the Cataloguing of Archaeological textiles,* London.

Glass

Harden, D.B. *et al.* 1987 *Glass of the Caesars,* Olivetti.

Krueger, I. 1987 Die Glasfragmente aus einer Grube bei St. Quirin in Neuss, *Beiträge zur Archäologie des Rheinlandes..*

Sauzay, A. 1870 *The Marvels of Glass-making in All Ages,* London.

Pottery

Green, C. 1982 *Drawing Ancient Pottery for Publication,* Association of Archaeological Illustrators and Surveyors, Technical Paper 2.

Hurst, J.G. *et al.* 1986 *Pottery Produced and Traded in North-West Europe, 1350-1650,* Rotterdam Papers VI, Museum Boymans - van Beuningen.

Miller, L. *et al.* 1986 *The Roman Quay at St Magnus House, London,* London and Middlesex Archaeological Society Special Paper No. 8.

Pearce, J.E. *et al.* 1985 *A Dated Type - series of London Medieval Pottery Part 2, London - Type Ware,* London and Middlesex Archaeological Society Special Paper No. 6.

Platt, C. and Coleman-Smith, R. 1975 *Excavations in Medieval Southampton, 1953-1969, Vol. 2, The Finds,* Leicester University Press.

Tyers, P. and Vince, A.G. 1983 *Pottery Archive Users Handbook,* Museum of London.

Flint and stone tools

Addington, Lucile R. *1986 Lithic Illustration: Drawing flaked Stone Artifacts for Publication,* Prehistoric Archaeology and Ecology series, University of Chicago Press.

Dauvois, M. 1976 *Précis de Dessin Dynamique et Structural des Industries Lithiques Préhistoriques,* Pierre Fanlac.

Martingell, H. and Saville, A. 1988 *The Illustration of Lithic artefacts: a guide to drawing stone tools for specialist reports,* The Lithic Studies Society Occasional Paper 3 and Association of Archaeological Illustrators and Surveyors, Technical Paper 9.

Tixier, J. *et al.* 1980 *Prehistoire de la Pierre Taillée I, Terminologie et Technologie,.* Cercle des Recherches et d'Études Préhistoriques.